ART AND POSTHISTORY

Columbia Themes in Philosophy, Social Criticism, and the Arts

Columbia Themes in Philosophy, Social Criticism, and the Arts presents monographs, essay collections, and short books on philosophy and aesthetic theory. It aims to publish books that show the ability of the arts to stimulate critical reflection on modern and contemporary social, political, and cultural life. Art is not now, if it ever was, a realm of human activity independent of the complex realities of social organization and change, political authority and antagonism, cultural domination and resistance. The possibilities of critical thought embedded in the arts are most fruitfully expressed when addressed to readers across the various fields of social and humanistic inquiry. The idea of philosophy in the series title ought to be understood, therefore, to embrace forms of discussion that begin where mere academic expertise exhausts itself; where the rules of social, political, and cultural practice are both affirmed and challenged; and where new thinking takes place. The series does not privilege any particular art, nor does it ask for the arts to be mutually isolated. The series encourages writing from the many fields of thoughtful and critical inquiry.

For a complete list of titles, see page 111

ART AND POSTHISTORY

CONVERSATIONS ON THE END OF AESTHETICS

ARTHUR C. DANTO
AND DEMETRIO PAPARONI
FOREWORD BY BARRY SCHWABSKY

Columbia University Press

New York

Columbia University Press
Publishers Since 1893
New York Chichester, West Sussex
cup.columbia.edu

Translation copyright © 2022 Columbia University Press
Arte e poststoria. Conversazioni sulla fine dell'estetica e altro, Demetrio
Paparoni & Arthur C. Danto © 2020 Neri Pozza Editore, Vicenza
Published by special arrangement with Neri Pozza Editore in
conjunction with their duly appointed agent MalaTesta Literary Agency
and the co-agent 2 Seas Literary Agency

Library of Congress Cataloging-in-Publication Data
Names: Danto, Arthur C., 1924–2013, author. | Paparoni, Demetrio,
author. | Schwabsky, Barry, writer of foreword.
Title: Art and posthistory: conversations on the end of aesthetics /
Arthur C. Danto and Demetrio Paparoni; foreword by Barry Schwabsky.
Description: New York: Columbia University Press, 2022. |
Includes bibliographical references and index.
Identifiers: LCCN 2021043484 (print) | LCCN 2021043485 (ebook) |
ISBN 9780231204767 (hardback) | ISBN 9780231204774
(trade paperback) | ISBN 9780231555692 (ebook)
Subjects: LCSH: Aesthetics.
Classification: LCC N66 .D25 2022 (print) | LCC N66 (ebook) |
DDC 701/.17—dc23
LC record available at https://lccn.loc.gov/2021043484
LC ebook record available at https://lccn.loc.gov/2021043485

Columbia University Press books are printed on permanent and durable
acid-free paper.

Printed and bound by CPI Group (UK) Ltd, Croydon, CR0 4YY

Cover image: Sean Scully
Cover design: Chang Jae Lee

CONTENTS

Foreword: Toward the Invisible Future by *Barry Schwabsky* vii

Preface xvii

In Judy's Room xxiii

1. History and Posthistory (1995) 1

2. Style, Narration, and Posthistory (1998) 25

3. The Angelic vs. the Monstrous (1998) 43

4. Art Criticism as Analytic Philosophy (2012) 53

Notes 91

Index 97

Photos follow page lxvii

FOREWORD

TOWARD THE INVISIBLE FUTURE

Barry Schwabsky

"In 1964," says Arthur C. Danto, "I published 'The Art World,' and it changed the whole direction of aesthetics."[1] He's not bragging; what he says is true. Or at least it's what, as an undergraduate philosophy major in the late 1970s, I was trained to believe. When I took a course on aesthetics, taught by the late L. Aryeh Kosman, who was a specialist in Greek philosophy, we did not start with Plato or Aristotle, or even with Kant or Hegel. We started with Danto on "The Art World." That essay changed the course of philosophical aesthetics, as I later came to understand, because it had proposed a new problem, or rather a newly noticed problem, one that had always been lurking in the background without being noticed: how in the world do some human-made things get to be art, and others not? Danto proposed an answer, but that's less crucial. A new problem opens a

door into new, sometimes vast spaces; a solution closes the door on familiar ones.

The problem Danto set himself to answer was a seemingly simple one: What distinguishes an art object from what he would later call "mere real things?"[2] This had never been an issue for art theorists before the twentieth century because most things considered art appeared too little like other things for anyone to puzzle over the matter. Even when they functioned like workaday things, they still looked quite different; the golden saltcellar that Benvenuto Cellini sculpted for Francis I of France may really once have been used for the seasoning of the king's food, but it is self-evidently no ordinary piece of tableware, either in its materials or its workmanship.

By Danto's time, however, some artworks had come to revel in their ordinariness. A numeral painted by Jasper Johns was still a numeral, though also part of a painting, and a bed incorporated into one of Robert Rauschenberg's combine paintings was still a bed. And one of Andy Warhol's Brillo boxes was indistinguishable, Danto claimed—I'd have to disagree, but that's another essay—from the one you'd find in the supermarket. So what distinguishes the two? Danto's answer: a theory. "It is the theory that takes [an object] up into

the world of art, and keeps it from collapsing into the real object which it is."[3]

There's something right about this: One has to have a certain idea of art to recognize one of Warhol's Brillo boxes as an artwork. But I'd add: That's not enough. To show why, let me give an anecdote: In 1989, one of my college friends, Tim Cone, a lawyer, purchased a work produced the year before by the then-up-and-coming artist Cady Noland. Its title was *This piece doesn't have a title yet*, but later the title was changed to *Fizzle*. In any case, Tim decided to throw a cocktail party to show off his new possession, which consisted, as I remember, of a metal milk crate filled with seemingly random junk— empty beer cans, the rearview mirror of a car, a lock and chain, and so on. I was fascinated to see how, as Tim's lawyer friends came in and he asked them, "What do you think of the new artwork?", they couldn't see it; they didn't know where to look. Certainly that strange little agglomeration of debris, which might have looked like something he hadn't had a chance to bring down to his building's trash room amidst all the preparations for the party, did not look like it. And yet of course it was. This was my own personal equivalent to Danto's encounter decades earlier with the Brillo box. But I drew a different conclusion, perhaps because although

I had the idea—you can glorify it as a theory if you like—*that* a Brillo box or a crate full of junk could be art, I didn't have a theory of *why*. Or perhaps I had no theory at all, but only a feeling—a strong feeling, and for that matter a stronger one than when I had previously seen a work by Noland in an art gallery.

But even without a theory of why a given object, in this case ascribed to Cady Noland, was a work of art, I did think I had an idea of *how*, in any case, it had happened. It has something to do with the artist, Andy Warhol, and his studio, dubbed the Factory, where the silk-screening was done. "If someone says it's art, it's art"—a statement attributed to Warhol's contemporary, Donald Judd—is not a theory but, really, a recommendation as to how to approach a situation of doubt. Warhol's say-so may not in itself settle the question of his work's art status, but it's where our examination of the case should begin. He thought it would be fun to make replica Brillo boxes as art, and many people, when they gave the idea a chance, found that it made sense, that it was rewarding to accept these things as art and consider the consequences. Now it's true that Michelangelo or even Manet could not have had this idea, and not only because there was no Brillo in their time; it might even be the case that those men had theories of art that would have forbidden such a possibility. But Warhol

did not need a new theory to make his Brillo boxes; he had only to ignore the old ones.

So Danto was right that it is not necessarily by looking at an object that we can determine whether it is an artwork. We have to know how and why it might have been said to be art. And just as a name attaches to a person, for example the physicist Richard Feyman, whom I might refer to without having any really accurate information about him—so averred Saul Kripke in a renowned set of lectures delivered in January 1970—it's because "a chain of communication going back to Feynman himself has been established, by virtue of his membership in a community which passed the name on from link to link," and I would say, similarly, that the art status of a Brillo box depends on a chain of communication reaching back to Warhol himself as the person who initially proposed that it could be an artwork.[4] (Sometimes a considerable or even decisive role in such communication is accorded to the institution of the gallery, but this is contingent; consider my encounter with Cady Noland's sculpture in a purely domestic context.) None of the people involved in this chain need have a settled theory of art—including the artist him- or herself and me—just as the people who use names need not have a theory of names. Here, I find myself getting close to Thierry de Duve's idea of art as a proper

name, that "in place of a theory you give examples. Each of them you baptize with the name of art, one by one"—only I disagree with his proposed concomitant, "The phrase 'this is art' is the expression of your judgment, arising case by case."[5] It's more like a wager than a judgment. Remember that although, when a child is christened, she is initiated into a church, there is no guarantee that she will remain there. As Danto observed in a somewhat (but only somewhat) different context, "in naming our children, we seek names that will embody the person we hope they will become."[6]

With "The Art World," Danto commenced a many-sided project in aesthetics, as developed in the books *The Transfiguration of the Commonplace* (1981), which Danto considered his most important book, but equally *The Philosophical Disenfranchisement of Art* (1986), with its notorious and widely misunderstood thesis of "the end of art," among other writings.[7] It may be more surprising that, in 1984, he also took up a calling in art criticism, above all in the *Nation*. As a philosopher, Danto may have envisioned art's "posthistorical" condition as one in which it would no longer present vital problems for philosophy; but he never meant that art had come to an end. As he tells Demetrio Paparoni, "I was talking about the end of a history"—we can put the

little word *a* in invisible italics—"not of the death of art."[8] With this end of history, as Danto's friend the painter David Reed realized, "Arthur's argument gave me freedom . . . I could do what I wanted."[9] Here, the Hegelian idea of history as the slow triumph of the idea of liberty means that the story's conclusion comes when "everyone is free and begins to build his or her own life. In that instant history ends, but life continues."[10] The philosopher's role may have been to chart the course of necessity, but in the realm of freedom the critic—the specialist, one might say, in appreciation and in making fine distinctions—comes to the fore and is perhaps all the more necessary when, despite the persistence of excellent artists, the overall situation is one of mediocrity, as Danto periodically complains.

In these conversations with Paparoni, an Italian art critic, curator, and editor whose erudition and inquiring spirit allow him to bring out the many sides of Danto's thinking—they are joined on occasion by the artist Mimmo Paladino and the philosopher Mario Perniola— we become privy to a discourse that is fresh and spontaneous, and in which the interlocutors challenge each other in unexpected ways. For instance: what, asks Paparoni, is the fate of "style" in an art that can become indiscernible from everyday things, or even from already

existing art? The answer, in Danto's view, is open: without "a privileged historical direction" art becomes pluralistic, but this plurality may be regulated by a stylistic canon that remains invisible to those of us who inhabit its realm: It may become perceptible in the future, and in ways that might surprise us.[11] It's for this reason that, as Danto says, "Deep interpretations are instead those that set aside the artist's intentions."[12] It is precisely in this space of unknowing that Perniola identifies, in Danto's thought, a third way between ideology and skepticism. But there is no guarantee that the path can be found, for, as Danto cautions, "What makes the present invisible is the invisibility of the future."[13]

Striking here is that when Danto turns to his own life history, he presents his most momentous professional choices as near accidents. As a young soldier catching sight in a magazine of some striking modern paintings, he decides to become an artist. In Detroit, he finds the beginnings of local success as a printmaker but, wanting to move to New York, applies "impulsively" to graduate school in philosophy.[14] As a philosopher, he asserts, "had no special interest in aesthetics," but a Warhol exhibition changed his mind, and, perhaps because his work in the field was so well received, "out of the blue" he was invited to be the *Nation*'s art critic.[15]

This career, as he describes it, might be thought of as quintessentially posthistorical, ruled not by a teleological narrative but by the interaction of liberty and chance. And yet we, looking at this life in retrospect— are we entirely wrong in seeing a destiny at work?

PREFACE

On multiple occasions, beginning in the 1990s and up until his death, I met with Arthur Danto and his wife, artist and illustrator Barbara Westman, the creator of numerous covers for the *New Yorker*. Danto and I would often go to exhibitions together at Manhattan galleries or visit artists' studios.

From 1983 to 2000 I was the editor and director of the contemporary art review *Tema Celeste*. Beginning in the early nineties, Arthur Danto was one of the contributors who gave the review its highest prestige. I also had the pleasure of being Danto's editor: in 1992, I had *The Philosophical Disenfranchisement of Art* translated and published in Italy, followed by his "Narrative and Style" in 1998, a brief essay, accompanied by our conversation, in which Mario Perniola also took part. That conversation is included in this book.

Though we had planned to collect our conversations in a single publication, after his death I chose to shelve the project. I decided to revisit it in 2016, when I presented my book, *Cristo e L'impronta dell'Arte* at the Readers' Circle (Circolo dei Lettori) in Turin. On that occasion, my friend and philosopher Tiziana Andina—the author of two books dedicated to Danto—claimed to have found the theories on beauty expressed in my book to be at odds with the theories that Danto's philosophy of art seemed to have helped eliminate. Aware of the fact that one's thinking is primarily defined through writing (an activity that I believe welcomes the opportunity to discuss ideas with others), I returned to the prospect of publishing our conversations, this time with an introductory essay that, in addition to focusing on Danto's ideas, would also clarify my positions.

In this essay, I did my best not to confuse my thoughts with Danto's; whether or not I succeeded is a different story. While several references and considerations do not come from Danto's books, they are certainly consequences of the analysis that I have gradually developed based on his ideas. Having known him, I am confident this would have pleased him, and that he would have stood by his usual explanations.

In an article featured in *Artforum* soon after Danto's death, artist David Reed recalls accompanying Danto to

a symposium on his writing at Columbia University in 2003:

> The night before, during the celebratory dinner, I saw the genuine respect and warmth with which he was treated by his philosopher colleagues. Not knowing the etiquette of such events, I was shocked the next morning when these same colleagues viciously attacked Arthur's ideas in their presentations from the podium. I didn't know that for philosophers such attacks are a form of respect. Arthur, delighted, and smiling, leaned over and whispered in my ear: "He's really trying to eviscerate me!" Along with Arthur's other artist friends, I sat in a protective circle around him, but he didn't need us. After each paper he stood up and replied extemporaneously, unbloodied and unrepentant to what he called their "bouquets of jabs and slashes."[1]

Having an intense intellectual exchange with a philosopher and art critic does not amount to adhering to his views in toto. While every intellectual has his own points of reference, he does not necessarily consider these to be his personal Gospel. At the same time, the interest elicited by Danto's ideas attests to how important

I considered the questions he raised to be—both in his writing and in our private conversations—and how essential it is for me to reflect on his conclusions, even today.

The first of our many conversations arose by pure chance. On February 9, 1995, Danto came to Milan to speak at the Accademia di Brera for a conference, La generazione delle immagini (The generation of images), organized by Roberto Pinto and Marco Senaldi. He planned to stay in Milan for a few days, which offered us the opportunity to spend some time together. The day after the conference, we paid a visit to the Pinacoteca di Brera, where we stood before Medardo Rosso's wax sculptures. We had no plans that afternoon. I knew that Mimmo Paladino was in Milan at the time, so I proposed we go visit him. Once there, the discussion became quite interesting, so I suggested we record it. The conversation was later published in *Tema Celeste*.

The subsequent exchange of ideas occurred primarily through fax and, later, email. The final text is more of an interview rather than a conversation. In 2011, due to the attention that the translations of Danto's books were receiving in China, the review *ArtChina* expressed interest in publishing an interview conducted explicitly for Chinese readers.[2] Danto's focus on the various stages of his life as an artist and scholar, as well as his extensive

examination of Greenberg, are the result of the Chinese review's wish to present the philosopher to its readers within the context of American art and criticism. This conversation, which was overseen by Danto and published the following year, can be found in the Italian edition of this book. It has remained unpublished in English until now. No text or book about art can claim to be complete; there is an abundance of information and reflections that can always be added. With respect to the Italian version, I found it fitting to include several considerations pertaining to On Kawara and his *Date Paintings*, Robert Gober's *Slides of a Changing Painting*, and Alighiero Boetti's *Serie di merli disposti a intervalli regolari lungo gli spalti di una muraglia* (Series of merlons arranged at regular intervals along the bastion of a wall).

The people who were directly and indirectly involved in the realization and publication of this book are numerous, and I am bound to forget someone. A special thanks is reserved for Danto's wife, Barbara Westman, to their daughter Ginger and to her nephew Fritz Westman, for encouraging me to press forward with this project. Thank you to my wife, Maria Cannarella, to my daughter, Ginevra, and to my friend and philosopher Elio Cappuccio, for their careful editing and valuable advice. Thank you to Nicola Samorì and Gianni Mercurio for discussing several passages of the introductory

text with me as I worked my way through my first draft. Thank you to Gian Enzo Sperone and to photographer Giorgio Colombo for the information they provided me regarding Boetti's *Serie di merli disposti a intervalli regolari lungo gli spalti di una muraglia*. I am deeply indebted to Giuseppe Russo, editorial director of the publishing house Neri Pozza, who both pushed for and made possible the publication of this book in Italy. Thank you to Wendy K. Lochner for having guided me through the realization of this new edition in Danto's native language. To be published by Columbia University Press is a great honor. I also owe a debt of gratitude to Barry Schwabsky for the scholarly preface he so generously provided, which I truly appreciate, and to Natalia Iacobelli, who has been translating my works for years. Finally, I would like to thank Sean Scully, whose art and persona are, in my mind, associated with the figure and thought of Danto. A special thanks to him for having designed the cover image, which he made with his iPhone. The use of new technology to create designs and "paintings" would have been a wonderful topic to tackle with Danto and to include in this book.

IN JUDY'S ROOM

In Arthur Danto's view, it was in the twentieth century, with the questions raised by Duchamp and later by Andy Warhol's Brillo Box, that Hegel's prediction came true—that is, that the appreciation and interpretation of a work, which was increasingly imbued with philosophy, would be entrusted to the mind rather than the eye. The crucial moment in which Danto brought into focus his personal theory on the "end of art" coincided with Warhol's exhibition at Manhattan's Stable Gallery, which he visited in 1964. It was at that time that he would focus on understanding what allows something to be considered a work of art in a particular moment in history, when in the past it would not have been considered as such.

Warhol's exhibition at the Stable Gallery introduced, for the first time, the now-famous wooden renditions of

common cardboard packing boxes used to transport merchandise, painted with synthetic polymeric paint and serigraphic ink. Warhol arranged the gallery as if it were a grocery store, filling the space with his boxes of Brillo pads, Campbell's tomato soup, Heinz ketchup, Kellogg's corn flakes, Mott's apple juice, and Del Monte peach halves. Though numerous products were displayed throughout the exhibition, Danto honed in on the boxes of Brillo pads—soapy steel wool sponges used to clean kitchen pans.

While Warhol's Brillo Boxes are slightly larger than the original boxes in printed cardboard, Danto rightly believed that this detail would not affect his theory. In fact, if we compare photographs of the original light-weight corrugated cardboard boxes with Warhol's renditions, there is no notable difference. While there may have been a perceivable difference when seen side by side in person, when Warhol's Brillo Boxes were displayed for the first time they were only appreciated as an artistic expression by those who knew—or were able to intuit—the conceptual dynamics from which they derived. Anyone seeing them in 1964, independently of the exhibition at the Stable Gallery, would not have recognized them as works of art. Had they not become famous, they would still generate the same misinterpretation today.

The original Brillo boxes were designed by James Harvey one year before Warhol would appropriate them. Ironically enough, Harvey had been an abstract expressionist artist with little success. His designs for his commercial boxes transmitted everything abstract expressionists detested: the banality of daily life, the attraction of common objects, and the immediacy of the visual message. Harvey designed the boxes in congruence with the criteria of commercial communication aimed at large masses. Harvey reportedly laughed when he first saw the boxes on display in the gallery. A simple object that was to serve as a container for a commercial product, Warhol had charged it with artistic significance. While he claimed to find beauty in everyday objects, Warhol did not choose boxes of commercial products in an effort to point out their beauty, but rather to imbue them with a new and different meaning.

Based on the observation that the corrugated cardboard Brillo boxes and the painted plywood reproductions appear nearly identical, Danto believed that the question we should have been asking was no longer "What is art?" but "Why is one thing considered a work of art while another virtually identical thing not?"[1] This "exquisitely philosophical" question, as he noted, finds its premise in Duchamp's readymades, created in New York between 1913 and 1917, which are not identifiable as

works of art according to the criteria of retinal perception. With a readymade, Danto explains, "the work is the thought plus the object, it being in part a function of the thought to determine which properties of the *object* belong to the *work*."[2] This definition can also be applied to Warhol's Brillo Boxes, which Danto claims had successfully carried out Hegel's precognition of the death of art.

But why attribute this achievement to the Brillo Boxes and not to the readymades? Danto's answer lies in the difference between an everyday object that has been elevated to a work of art and a work of art that is identical to an everyday object. In other words, while on a visual level a readymade becomes an entirely different thing with respect to the original object, the same cannot be said for Warhol's painted plywood reproductions of the Brillo Boxes, which, visually, appear to be identical to the original Brillo boxes made of cardboard.

While Duchamp argued that making use of factory-made objects was "a form of denying the possibility of defining art," and that his readymades were devoid of sense and meaning, in reality they cannot escape a narrative that allows them to be defined as works of art.[3] Let us take the example of Duchamp's snow shovel, the first American readymade. Before hanging it from the ceiling, the artist wrapped a thin metal foil around

the handle upon which he wrote, "In advance of the broken arm," followed by his signature and the date. On more than one occasion, Duchamp stated that it was "a truly useless meaning . . . a phrase which wanted to say nothing."[4] Nevertheless, it is undeniable that, visually, the object became something very different than the simple snow shovel purchased at a general store between Columbus Avenue and 60th Street. Duchamp's objects, which were found in a ready state and then manipulated, responded to the need to deny the possibility of defining art—they were not made to be presented to the public or to be contemplated. And yet they were inevitably destined to be displayed in spaces dedicated to hosting art. This is what happened with his readymade *Fountain*, which he attempted to display in 1917 at the Grand Central Palace, attributing it to a certain R. Mutt, in the first exhibition of the Society of Independent Artists, an association founded as a reaction to the traditionalist positions of the National Academy.

Inspired by the Société des Artistes Indépendants in Paris, the Society of Independent Artists was open to anyone who wished to participated in its exhibition, in exchange for a small fee. In an effort to provide a level playing field to all artists, it was decided that no prizes would be awarded. Despite the 2,123 works by 1,200 artists featured in the exhibition, after extensive discussions,

the urinal that Duchamp had elevated to a work of art by turning it upside down and transforming it into a fountain—it reversed the direction of fluids, after all— was deemed inadequate for the exposition by several members of the organizing committee. It was consequently removed before the inauguration of the exhibition, and a reproduction of the work was never included in the catalog. *Fountain* was later found on display behind a partition.

The story behind *Fountain* reveals the artist's inability to contain the sense and meaning of a work within a limited space, much less to control its destiny. The only way an artist can control the outcome of a work is by planning and carrying out its total destruction. In other words, readymades are conceived of as works lacking sense and meaning, yet they acquire these the moment in which the process that brought the artist to create them is analyzed. Although Duchamp stated that his readymades were not meant for an audience, after the closing of the exhibition of the Society of Independent Artists, after the artist behind the work had been brought to light, *Fountain* was displayed for a period of time at Alfred Stieglitz's 291 Gallery.

As works of art that are presented as common objects, both readymades and Warhol's Brillo Boxes lack the

narrative structure of figurative art and the compositional structure of abstract art. According to Danto, the distinction between the object and the artwork is no longer made based on their form; instead, it is guided by an interpretative process, which, in the case of the Brillo Boxes, makes use of a comparative method involving a pair of objects that refer to one another, of which the original is difficult to distinguish from the copy. Danto's philosophical interpretation of an artwork develops based on the possibility, or the impossibility, of recognizing these identities and differences.

A comparative analysis between Duchamp's work and that of Warhol elicits a reflection on the uniqueness or seriality of an artwork. By procuring objects that should leave us feeling indifferent as they escape the concepts of taste and savoir-faire, Duchamp is able to remove the work from all aesthetic categorizations. Though he preferred that his objects be perceived as anonymous, once the artist's manipulation is noted, they become anything but.

Let us return to Duchamp's *In Advance of the Broken Arm*. It is not identical to the snow shovel found in a store, which began as a common object with no aesthetic qualities to lay claim to. Conversely, the boxes designed by Harvey could in fact claim an aesthetic quality, as

they sought to capture the attention of American consumers. A visual comparison between the original cardboard box designed by Harvey and Warhol's Brillo Box reveals that the two different objects convey the same image. Visually, very little was altered when the original cardboard was substituted with plywood—a material that would guarantee the pop art work's conservation through time. Yet Warhol did not choose the box for its aesthetic qualities, but because it expressed the essence of American consumer society.[5]

The difference between Duchamp and Warhol is that, while the former chooses an object due to its lack of aesthetic qualities, the latter chooses his object by virtue of its own eye-attracting nature. Nevertheless, as soon as he makes a *copy*, he eliminates those qualities, and the original purpose is lost. This consideration prompts Danto to ask himself why Warhol's box is a work of art, while Harvey's is not. His answer: Warhol's work poses a series of philosophical questions that the commercial box does not. Based on these considerations we can begin to understand why Danto considers Warhol, more so than Duchamp, to be the first artist to prove that art—at the end of its journey—is no longer able to give a definition of itself. It now needs philosophy to explain its raison d'être.

Danto defined a work of art as an "embodied meaning"—that is to say, "an object that is about something and embodies its meaning."[6] In other words, an artwork carries with it the meaning of the object or image to which it refers, or, in an extreme case, that it has appropriated, making it the driving force behind a series of questions that arise from its new identity and from the historical context in which it emerges. Our understanding of it thus requires an analytic comparison that does not necessarily involve resorting to aesthetic parameters. Contrary to what George Dickie contended when he misinterpreted Danto's idea, this approach does not see the artist as the author of artifacts that will one day be faced with aesthetic categories. According to Dickie, even if an artifact, in its inception, is outside of aesthetics, it will ultimately end up falling back within one of its categories. This, in Danto's view, is not the case.

Having experienced the dynamics of art from the inside, both as an art critic and philosopher, Danto is well aware that for modern and contemporary artists the search for beauty is more dangerous than the plague. When we go to an exhibition of modern and contemporary art, and we find ourselves before an artwork, we do not seek something that leads us to the pursuit of

beauty. If and when our approval brings us to define a work as "beautiful," we mean to say that the work has stimulated our attention due to the way in which it was made, the implications it involves, and the considerations it is able to foment. We do not see it as being charged with tension and well made because of its composition, sense of proportion, or color harmony. Rather, we are attracted by the fact that it is a source of stimulation for our mind more so than for our eye.

Warhol's Brillo Boxes did not come without consequences—they even generated reflections among artists of subsequent generations. Artists like Richard Prince, Cindy Sherman, Sherrie Levine, and Mike Bidlo make clear through their works that Warhol's 1964 exhibition at the Stable Gallery did not mark the conclusion of the artistic research begun by Duchamp; it was instead a mere moment of transition. Confronting works from the early days helps us understand why Danto prefers the term *posthistorical*—as opposed to *postmodern*—art. This definition refers to the wide array of artistic styles and expressions that have coexisted in the contemporary art scene since the late 1970s, avoiding all manifestos or theories that establish the characteristics that define their espousal to the spirit of the time. These artists rebuffed any attempt to interpret their work as part of a codifiable phenomenon based on style. Their actions responded

to such a pronounced need that the effects were even felt even by artists from the previous generation. In the mid-1980s, Roy Lichtenstein, who in 1965 had taken Willem de Kooning's brushstroke and turned it pop by making it into a ben day print, would place de Kooning's visceral and subjective brushstroke side by side with his own pop art rendition in the same composition. This was an explicit declaration that art no longer aligned with the formal oppositions theorized by Clement Greenberg and the vast portion of American criticism that followed in his footsteps.

Artists began operating outside of the boundaries of groups and tendencies after they broke free from a linear and progressive view of history. The new climate that was being established in the late 1970s was such that every artwork that had ever been produced in history could be emulated. A radical shift took place in relation to the end of the 1940s, when Greenberg declared that Surrealism lacked the requisites to be considered a modern movement based on his own definition of modernism. The highly ideological and formalist configuration of Greenbergian theory had created a rigid grid in which all artistic styles were to be pigeonholed, at the expense of being excluded.

In the mid-1970s criticism imposed its views yet again, declaring that figurative painting was dead—it no

longer had a reason to exist, as it was the expression of a historical period that had concluded. The amount of time that has passed from this critical view of the postwar period allows us to see more clearly that figurative painters worked in parallel with the experiences of the abstract expressionists of the 1940s and 1950s and of the minimalists and conceptualists of the 1960s and 1970s. Once deemed conservative and opposed to progress, today these artists are widely recognized as expressions of their times. Who today would argue that the figurative paintings of Francis Bacon, Lucien Freud, or David Hockney, from the postwar period onward, as well as the paintings by Jackson Pollock and de Kooning from the 1950s, and later those by Robert Ryman, and the sculptures by Sol LeWitt and Donald Judd in the 1960s and 1970s, were not expressions of their times?

Of the artists who dismantled the linear and progressive vision of art, the appropriationists operated in a more radical manner than the citationists and the neo-expressionists. Cindy Sherman was among the first to launch the appropriationist phenomenon in the late 1970s, crippling the illusion of those who thought she would unequivocally tend toward neo-Expressionism. Between 1977 and 1980 she worked on the cycle *Untitled Film Stills*, sixty-nine photographs of herself posing as the prototypical females featured in films from the 1950s

and 1960s. Sherman's images are reminiscent of film stills, posters, autographed photographs of famous actresses for fans, paparazzi shots, and photo sessions featuring actresses going about their daily lives that are meant to feed the curiosity of the public. Sherman's photographs also imitate the quality of these different photographic materials and characteristics based on their specific use.

Sherman's *Untitled Film Stills* do not faithfully recreate existing photographs. Rather, they reconstruct an image that already contains a fictional scene in which the subject interprets a role. Nevertheless, they appear strangely real. By becoming one with the prototypes in the media, the artist underscores their role in the construction of our identity, which is conditioned by the gaze of others. Albeit disguised in the role she is interpreting, the artist's identity emerges thanks to the overall vantage point of the pictures, which seem to belong to another time.

In 1981, after stating that she was interested in making art that overtly attested to human suffering, Sherrie Levine held an exhibition entitled *After Walker Evans*, which featured images she had rephotographed two years earlier from the catalogue for Walker Evans's exhibition, *First and Last*, held at the MoMA in 1978. Evans had photographed a farmer's family during the Great

Depression in Alabama in order to document and denounce their difficult living conditions. Levine did not disown the social commentary expressed by those photographs, which revealed the lack of attention the lower classes received from the government. By faithfully reproducing them, Levine raised a series of questions related to the rights of reproducing images that were not originally works of art, but that had assumed the status of such over time. Levine sheds light on the concepts of the authorship, originality, and reproduction of artworks. Rephotographing Evans's photographs from his catalogue was for Levine a way of exploring the language of an original work and the possibility of making its contents current. In fact, Levine used these images to allude to the ramifications of the policies of then–U.S. president Ronald Reagan among the lower classes.

A series of rephotographed photographs, Levine's *After Walker Evans* reproduces an original image without making modifications. According to Levine, all that is required in order to make the outcome of the appropriation of a well-known artwork original is the process of conceptual reelaboration, which adds meaning to the reference image.

Richard Prince continued in the same vein when he analyzed the way in which advertising influences social models, transforming them into stereotypes. Prince

appropriated images from newspapers by photographing them and reproducing the majority by simply blurring them or accentuating their film grain. The preferred subjects for his initial works were groups of people belonging to the same social milieu: motorcyclists, surfers, gang members. In order to make clear that they were appropriations of old photographs, Prince accentuated the granularity of enlargements of the photographic images. In his series *Cowboys* (1980–1986), Prince photographed details of photos from the Marlboro ad campaign in order to highlight how certain aspects of real life are entirely filtered in our conscience by the images we are fed by the mass media.

Another noteworthy instance of appropriation is that of Mike Bidlo, whose work consists of producing replications of works by other artists. For his cycle of paintings *Not Pollock* from 1982, Bidlo closely examined the photographs and films taken by Hans Namuth to document the way in which Pollock worked—even studying the psychological and biographical background of the famous drip painter. Before that, Bidlo had recreated Peggy Guggenheim's living room in her house in Beekman Place, having a performer reenact an episode from Pollock's life. In 1984, for the exhibition *NOT Andy Warhol's Factory* at the MoMA PS1, Bidlo also recreated Andy Warhol's Factory, in which performers—most of

whom were artists—impersonated the frequent visitors of the Factory, or the iconic characters portrayed by Warhol. Oftentimes, two different performers would play the part of the same person, emphasizing the notion of the *double*.

Danto and his wife, Barbara Westman, owned a Brillo Box—the most well-known version, set against a white background. They kept it in the room where they would receive guests in their Upper West Side apartment, facing the Hudson River. But theirs was not a Brillo Box by Warhol; it was a replica by Bidlo (*Brillo Soap Pads Box/Pasadena Version, 1969*, made in 1991). Bidlo did not limit himself to reproducing works by Warhol alone; in addition to his replicas of drip paintings by Pollock, Bidlo appropriated works by Picasso, Morandi, Matisse, Brancusi, Léger, Klein, and many others. In 1996, Bidlo held an exhibition entitled *Not Andy Warhol* at the Galerie Bruno Bischofberger in Zurich, where he displayed his Brillo Boxes in the same manner in which they had been presented by Warhol at the Pasadena Art Museum in California. Naturally, as in the case of other appropriationist works, the legitimization of the work adheres to precise theoretical criteria, clarified by the title, which reveals its nonoriginality. For example, in the case of the Brillo Boxes, the title

is *Not Warhol (Brillo Boxes 1964)*, followed by the date of the reproduction.

Bidlo's Brillo Boxes were interesting to Danto due to the fact that, insofar as a copy of a copy, they carried with them the many questions surrounding Warhol's originals, in addition to new questions. The first of these is: What made Bidlo's Brillo Boxes acquire the dignity of an original artwork when, in former times, they would have been defined as a copy of a copy? This new question led Danto to maintain that if Warhol's Brillo Boxes are purely philosophical works, then Bidlo's boxes—which are inspired by them—are works of applied philosophy, which Danto describes as philosophical comparativism.

The works of the artists in question reveal that beginning in the late 1970s a new way of relating to the concept of time began to gain ground. The vision of time expressed in the works of these artists could not have been foreseeable in the 1960s, and to some degree it remained that way for some time, even after Warhol presented his Brillo Boxes, the implications of which necessitated Danto's analytical intervention.

When we consider art from the 1960s and 1970s, we can identify remnants of a linear and progressive conception of history in the works of French Polish artist Roman Opalka (1931–2011), Japanese artist On Kawara

(1932–2014), and Italian artist Alighiero Boetti (1940–1994). A comparative analysis of the different ways of relating to time, with the implications these differences assume in relation to a narrative of history, reveals just how important it was in the late 1970s to question the concept of the linear progression of history. It was, first and foremost, this new vision of time that marked the shift from modernism to postmodernism.

In 1965, Roman Opalka launched his comprehensive project *Opalka 1965/1—∞* (1956–2011), which he would continue until his death. In his first work, Opalka painted a sequence of numbers starting from the number 1, with a thin brush dipped in white paint, against a black background. When the time came to work on the second canvas, he began with the next number in line following the last number on the previous canvas. He continued to do this until his final painting, which he completed in 2011. The numbers on the canvases are written horizontally, side by side, all in the same size. Opalka only dipped his paintbrush when it was completely dry, resulting in the varied density of the white paint of the numbers. The canvases, collectively entitled *Détail*, are equal in size and are distinguishable by their first and last numbers.

In the 1970s, Opalka enhanced his project by adding new elements. He began to lighten the background

of each new *Détail* by progressively adding 1.1 percent of white paint (in 2008 he would ultimately paint white upon white). He also began taking photographs of his face each time he finished a painting, using the same frame. He even began recording his voice, while counting in Polish, as he painted his numbers.

Opalka's work confronts the progressive and linear flux of time, which flows in parallel to historical events—datable and recordable like the progressions of his paintings and self-portraits. Opalka's vision of time shares strong points of contact with that of On Kawara and Alighiero Boetti. In fact, we can more deeply understand the work of one by comparing it with the work of the others. Between 1966 and 2014, Kawara painted the date—against either a red, blue, or gray monochromatic background—which he wrote in white, in the language and format of the country in which he found himself at the time. If the particular country did not use the Latin alphabet, the artist relied on Esperanto, an artificial language developed at the end of the nineteenth century with the intention of overcoming linguistic barriers.

Entitled *Today*, but also known as *Date Paintings*, this cycle of works was painted with an obsessive meticulousness on canvases of varying formats. Moreover, the series was driven by the method and rules the artist gave himself, which included the destruction of any work not

completed by midnight of the day it began. On the back of each canvas, Kawara affixed a typewritten note that related the work to a feeling or emotion, a current event featured in the daily newspaper, or something he had done that day. Seen in a sequence, the paintings follow the logic of a calendar, but Kawara associated them with events that had meaning for him personally, or for the community at large. The need to store his *Date Paintings* in an organized fashion as they accumulated day after day prompted the artist to construct cardboard boxes lined with newspaper cutouts. Though they were not created to be put on display, Kawara presented the boxes together with his canvases on multiple occasions.

Unlike conceptual artists, Kawara never provided explanations of his work. Yet a few biographical details may be helpful to understanding what exactly inspired the artist to create his *Date Paintings*, his telegrams, his postcards, and more—anchorages that link history to the "here and now." We know that Kawara was a good student, but that soon after the atomic bombings of Hiroshima and Nagasaki, when he was just thirteen years old, the artist began answering his teachers' questions by responding, "I don't understand." We also know that in the early 1960s, Kawara was moved by the Altamira cave paintings, which are thought to be over fifteen thousand

years old—a mark left by humans in an abyss of time to which we can only give an approximate date. We know, therefore, that as a young boy he was impacted after discovering how little it took for humanity to annihilate itself, and we know that, years later, when faced with the Altamira caving drawings, made by the hands of man, the artist confronted *writing* that became art, dating back thousands of years.

As we have said, Kawara's *Date Paintings* are accompanied by notes such as: " 'June 22.1966: 'The 25th Anniversary of Adolf Hitler's attack on the Soviet Union'; May 24.1966: 'The Soviet central Asian city of Tashkent was rocked by a new strong earth tremor'; May 29, 1966: "I am afraid of my 'Today' paintings"; February 8, 1970: A huge bomb goes off at the South Vietnamese National Press Centre in Saigon; May 29, 1971: "I got up at 12.06 p.m. and painted this.' " These notes, which were typewritten in order to escape the subjectivity that handwritten notes would inevitably bring with them, allowed Kawara, day after day, to painstakingly connect the passing of time to historical events and personal experiences. Their association with dates reveals to us that behind the cataloging of a day through conventional codes, there are events—both small and large—and there are individual and collective actions. Like all of

Kawara's works, his *Date Paintings* are a reaction to humanity's risk of disappearing, without leaving a trace behind.

The date in Kawara's works acts as a foothold that prevents us from becoming lost in the abyss of time. It is the point of intersection between history and one's personal stories; it is the recording of the here and now. It is of little surprise that a person who experienced the traumatic events and devastation of nuclear attacks in his own country would feel the need to keep track of time in order to shed light on what lives and breathes, shielding it from being lost in oblivion. Thus arises the obsessive precision with which the artist applied four layers of paint on his canvases, only to then sand then and dust them, before adding the date in a sharp white font, as if it had been printed. The care with which these paintings were created is like that of a craftsman who aims to achieve maximum precision. Furthermore, since the paint covers the lateral edges of the canvases, we perceive them as autonomous objects more so than paintings. While the *Today* series might formally suggest a relationship with the objectivity and inexpressiveness of minimalism, it also detaches itself from it insofar as it encompasses the subjectivity of the artist and does not exclude the sentimental dimension.

Also included in Kawara's project of defining time by binding it to the here and now are the postcards he sent—never written by hand—in which the date is indicated by the postmark, and the hour of shipment is recorded with the aid of the postal stamps. Other works that follow the same logic are his telegrams, calendars, or typewritten letters, in which, much like a journal, Kawara records moments from his life, lists of names, and inventories of paintings.

While the chronological advancement of time plays a fundamental role in Kawara's body of works, in which a progressive view of history is presented, other indications suggest that the artist's interest was not to show that history follows a linear development, but that each day is to be considered as a part of the whole, like something of value whose memory is not to be wasted. We perceive something similar in the works of Alighiero Boetti, who used postcards and telegrams in his examination of space and time. His work *Serie di merli disposti a intervalli regolari lungo gli spalti di una muraglia* (Series of merlons arranged at regular intervals along the bastion of a wall) is composed of thirteen telegrams sent by Boetti to his gallerist, Gian Enzo Sperone, between 1971 and 1993, at precise time intervals. The first telegram, sent on May 4, 1971, reads: "2 days ago it was May 2, 1971."

The second telegram, sent on May 6, reads: "4 days ago it was May 2, 1971." The number of days separating one telegram from the last is doubled each time, progressively increasing the distance in time between the mailings and the dates written on the telegram. Displayed side by side, the open telegrams recall the shape of merlons on medieval city walls, which is most likely to have inspired the title of the work.

Boetti had created a plexiglass case that could accommodate fourteen telegrams, but the space for the final one, which was to be sent in 2017, provided that the artist was still alive, remained vacant. These telegrams give form to a continuous work that, like those by Opalka and Kawara, was interrupted by the death of the artist and transmit the same feeling of contrast between the segments of time occupied by our lives and time's infinite incrementation. Therefore, while Opalka, Kawara, and Boetti give shape to a linear conception of time, once they relate time to personal experience, they allow for a fundamental circularity to merge. This is because, in the dimension of memories, an event that occurred in the past is still present in our personal experience and can influence our future decisions. In other words, once the objectivity of the passage of time is indicated by a postal stamp (Kawara, Boetti), the personal experience that brought the artist to a place and that led him to send a

postcard or telegram intersects with the absolutely objective data attested by the post office. It is from this intersection that the superimposition of a linear vision and a circular vision of time arises.

This concept, which, despite their differences, is traceable in the works of Opalka and Kawara, as well as in Boetti's postal works, is not reflected in the tapestries of political planispheres, known as *Mappe*, which Boetti commissioned to be made in Afghanistan and Pakistan. In fact, these tapestries date and record a progressive and linear temporal development of history. Preceding this series of maps was *Planisfero politico*, a work from 1969 featuring a black-and-white print of a map of the entire Earth's surface, upon which the artist highlighted countries using the colors and patterns of their respective flags. Later, in 1971, Boetti began commissioning tapestries to be woven in Afghanistan featuring planispheres, upon which he would periodically modify national borders in accordance with political events. Each planisphere was different from the next—a testament to the progressive variations in borders and the way they manifest in time, revealing the distributions of political power. The final map of this series, created in Pakistan between 1992 and 1993, features a planisphere after the fall of the Berlin Wall and the dissolution of the Soviet Union.

Let us now compare the works of Opalka, Kawara, and Boetti with that of Japanese artist Hiroshi Sugimoto, whom we can consider a precursor of posthistoric art. In his multiple series of black-and-white photographs, which he began taking in 1976 with a late nineteenth-century-style view camera, Sugimoto subverts the concept of time. His 1976 cycle *Dioramas* features photographs of prehistoric animals and primitive men dressed in animal pelts from dioramas found at the American Museum of Natural History in New York City; the Izu Waxwork Museum in Shizukoa, Japan; and the Movieland Wax Museum in Buena Park, California. While the representations appear real, the human figures are in fact mannequins, and the animals are stuffed or fake, inserted into artificial landscapes against realistically painted backdrops. The photographic images seem to convey scenes that were captured as they happened. Sugimoto pointed out that when he visited New York's American Museum of Natural History for the first time in 1974, he felt as though he was seeing something real, despite knowing that the dioramas were artificial. In relation to the historical-temporal reality of the subject, the image narrates something true, within the bounds of history. Conversely, in relation to the historical-temporal reality of the photograph, the image falls outside of history. In the end, the date of the

image included in the caption reveals that the photograph attempts to make something that is not from our times come off as true. The temporal distance between the time of the photograph and the depicted subject is thus nullified, as if it were possible to travel in time.

The same phenomenon occurs in Sugimoto's photographic portraits of historical figures at Madame Tussaud's wax museums in London and Amsterdam. In several of these photographs, portraits of historical figures such as Anne of Cleves and a young Fidel Castro are shown against a neutral backdrop. Judging by the date of the pictures, 1999, their historical-temporal dimension is dubious. It would have been impossible to portray the figures in 1999 as they appear in the photographs. At the same time, the photograph does not lie; the year of the work is indicated in the caption. Sugimoto once wrote in reference one of his portraits, "In the sixteenth century, Hans Holbein the Younger, German court painter to the British Crown, painted several imposing and regal portraits of Henry VIII. Based on these portraits, the highly skilled artisans of Madame Tussaud wax museum re-created an absolutely faithful likeness of the king. . . . I remade the royal portrait, substituting photography for painting. If this photograph now appears lifelike to you, you should reconsider what it means to be alive here and now."[7]

We ought to consider Sugimoto's other cycles, as well. In the photos from his series *Theaters* (begun in 1976), which feature large theaters, cinemas, and drive-ins, subjects in motion ultimately dissolve as a result of a prolonged exposure time. A single photograph captures all of the movements that pass in front of the lens, which our eye is no longer able to perceive. Due to the prolonged exposure time and the overlapping of all sequences that cross the frame on the film, the big screen becomes a glowing white rectangle: as they accumulate, the images reciprocally cancel each other out. The photograph thus becomes a metaphor for life—it reveals that we are made of time, and that all that once was remains encapsulated in a single moment in which everything is present simultaneously. Here, everything coincides with nothing. The passage of time, which should mark a shift from one phase of life to the next, gives rise to a non-progressive vision of history. A comparison of Sugimoto's series of photographs with paintings by Claude Monet (1840–1926) further conveys how the linear and progressive vision of time is innate to modernism, while revealing just how radical the turning point was that brought us to define our times as postmodern or posthistorical at the close of the 1970s.

In 1890, between the end of August and the beginning of September, Monet began painting the first of a

series of twenty-five paintings of haystacks. Begun en plein air and completed in-studio, each canvas captures a variation of the incidence of light in accordance with the time of day and the season. Monet worked on multiple canvases simultaneously until winter, and he planned to exhibit them all together—or at least to present a large group of them—in order to display their development through time. These paintings simply narrate the passage of time, highlighted by what artists then called *envelope*: the ability to capture within a painting the effects of light on nature at any given moment of the day. "Seeing those haystacks together," writes John Sallis, "we can see, beyond each individual painting, time itself, time made visible, or, rather, the result of the combination of moments made visible by the different paintings."[8] It is clear that what Monet depicts is time recording a moment. The same intention, with different implications, is found in the recently discussed series of works by Opalka, Kawara, and Boetti.

Robert Gober confronts the idea of time as an agent of transformation in his *Slides of a Changing Painting*. This work is a fifteen-minute projection of a selection of eighty-nine slides that document the continuous changes made to a painting on panel, which the artist worked on between 1982 and 1983, transforming it every time. Over the course of time, the first version of the painting had

entirely changed. In this metamorphosis of painting we perceive the instability of reality, which is never the same as it once was. *Slides of a Changing Painting* suggests that the work is laden with a future only the artist is able to bring out, and that it possesses the potential phases of its transformation. This does not involve a progressive vision of time bound to history: Gober does not intervene in the work of others, but only in his own work. Artists like Sugimoto, Cindy Sherman, Sherrie Levine, Richard Prince, and Bidlo rewrote something that already existed and projected it in the present, changing its meaning. Conversely, with *Slides of a Changing Painting*, Gober records the way in which the artist operated on his own work over time. By photographing the different transformative phases of the work, he removes them from oblivion and affords them to history.

Among the artists who challenged the linear and progressive vision of time, Sean Scully and David Reed occupy a prominent place in Danto's narrative. In his book *After the End of Art*, Danto initiates his discussion on posthistory by examining a video by Reed from 1994 entitled *Judy's Bedroom*. In 1992, by digitally manipulating certain scenes from the Alfred Hitchcock film *Vertigo* (1958), Reed substituted an anonymous floral still life on the wall of Judy's bedroom with one of his abstract paintings from 1990 (no. 328). The artist then

reconstructed Judy's hotel room at the San Francisco Art Institute, again substituting the painting in *Vertigo* with one of his paintings, which he included both in the bedroom and in the scene from his digitally modified video, playing on an endless loop on a television set in front of the bed.[9] Reed does not consider his works to be installations; he prefers to call them *ensembles*, noting that everything operates based on the fact that the painting is perceived as if it were in a real bedroom and not in an environment created for a museum exhibition.

With regard to this work, Danto emphasizes the "historical impossibility" featured in the video and in the ensemble *Judy's Bedroom*: a painting by Reed in 1990 could not have been featured in a Hitchcock film from 1958. The video thus presents a hybrid historical time: the product of two different and distant temporal moments, incompatible with a linear and progressive vision of time. It would have been normal to find a painting in a Hitchcock film from centuries prior—this would not have disrupted the linear concept of time. The question posed by Reed and stressed by Danto is that when *Vertigo* was shot it would not have been possible to imagine that such a painting could have been produced in the 1990s. "The unimaginability of future art," writes Danto, "is one of the limits which holds us locked in our own periods."[10]

At the core of Danto's theory is the concept of the "end of art," formulated by Hegel in his final *Lectures on Aesthetics* (1828). Hegel argued that art would reach its end when it no longer could provide a definition of itself, at which time it would leave the task to philosophy. According to this view, art was self-sufficient up until it needed philosophical definitions to legitimize its very nature; its cycle would conclude when it could no longer rely on the eye alone. In other words, according to Hegel, art would reach the end of its journey when spiritual content would gradually triumph over sensible form, authorizing philosophers to give it a definition. Art would then espouse the language of philosophy, recognizing the supremacy of the intelligible over the sensible. As we have said, for Danto this turning point was marked by Warhol's Brillo Boxes, as it was the first instance in which a contemporary artwork was identical to something else that had been made before. For this very reason Danto asks the following question: When a contemporary artwork is visually similar or identical to another made in the past, does this mean that it denies its historical moment? The answer is: no. It will still express its historical moment thanks to its embodied meaning, thanks to the fact that it carries with it the motives that prompted the artist to appropriate a work made by someone else in the past—the difference being that its

meaning will not be defined by its visual value, but by its philosophical motivations.

For Danto, the concept of the "end of art" does not imply that creating art no longer makes sense, or that art is dead, as is widely believed by those who insist on giving a literal meaning to the words that express this concept. Danto points out that, in spite of the fact that one of his texts happened "to have appeared as the target article in a volume under the title *The Death of Art*," whose title did not reflect his line of reasoning, "it was not my view that there would be no more art, which 'death' certainly implies, but that whatever art there was to be would be made without benefit of a reassuring sort of narrative in which it was seen as the appropriate next stage in the story. What had come to an end was that narrative but not the subject of the narrative."[11] Art itself was not coming to an end, but, rather, one way of understanding it and with it a certain way of conducting art criticism.

Despite asserting that the main objective of most contemporary art is not to offer an aesthetic experience, Danto did not deny that certain art puts aesthetics into play. On the one hand, he tells us that the pursuit of aesthetics was not "the main goal of most of the art made in the course of art history," while, on the other hand, he confirms that "there is unmistakably an aesthetic

component in much traditional art and in some contemporary art."[12] While Danto's objective was to identify the mandatory requirements for an object to be recognized as an artwork—requirements that do not necessarily include an aesthetic component—he still acknowledged that, alongside the many works that followed the lead of Duchamp and Warhol, there were other no less valid works that took different paths. Danto does not say that a contemporary work must not be beautiful; he says that it can exist beyond beauty. Moreover, he emphasizes how "just possibly the disgusting, as logically connected to beauty through opposition, can also have the connection with morality that beauty does."[13]

By referring to the "intrinsic morality of beauty," and not simply to "beauty," Danto shifts his focus to ethics. The ethics to which he refers is that of the artist, who confronts the concept of beauty unwillingly. Having been an artist before becoming an art critic and a philosopher, Danto understands that while art can be theorized and addressed philosophically, it expresses itself through forms, which are redefined from time to time based on the needs of the artist. It is this continuous redefinition of form that brings the concept of the "intrinsic morality of beauty" into play, which consists of the artist's ability to overcome the temptation to produce an object that will enchant the spectator. A work

that is "liked"—however this concept may be inter-
preted—is a work that caters to a widely acquired taste,
which for an artist means betraying himself and falling
into vulgarity.

In the 1990s, Danto and I were both friends with
Sean Scully, whose work is characterized by the study
of aesthetics, though far from the search for a notion of
beauty. Danto himself points out that, after Warhol,
Scully is the artist he has written the most about, despite
the fact that his art does not generate useful questions
for a philosophical definition of art.[14] As a philosopher,
Danto sought to understand why Duchamp's readymades,
Warhol's Brillo Boxes, and the work of the conceptual-
ists and minimalists fell under the scope of art. Not
immediately recognizable as art, these works require
philosophical support in order to be legitimized. Scul-
ly's work, however, does not need any philosophical
legitimization. The questions his art poses are relevant
to art critics, more so than to philosophers. In my view,
the main question concerns the concept of being "well
made"—the painting's ability to accompany the narra-
tive with a rare expressive power ascribable to the hand
of the artist. In addition to knowing how to interpret
what is hidden beneath the perceivable surface of the
painting, confronting a work by an artist like Scully
requires knowing how to identify its lineage and its

implications. In his discussions on the concept of the "soul," for instance, Scully looks not only to Rothko, but to Cimabue and Titian, whom he considers to be "two great transcendentalist artists." The impact of the hand, which is inherently antimodern, is fundamental. "The hand-painted surface carries with it the unbearable weight of history," Scully explained in a conversation of ours in 1992. "This is a potentially dampening and paralyzing obstacle. . . . I don't think it would be possible or desirable to formulate an interesting style based on harmony, as I don't believe that this would express a vital truth. . . . Since the problem of beauty and harmony is relegated to the sidelines, relations express an idea of collision and fracture."[15]

Reed also believes that beauty has something to do with morality and danger. In our written exchange from 1993, Reed claimed that Danto used the word "beauty" in a rather unusual way. "At times," Reed wrote, "I thought that for him 'beauty' had more to do with morality than with danger. . . . Anything that is beautiful carries a sense of danger."[16] Reed summarizes Danto's ideas as well as the work of contemporary artists: the danger to which he refers is the very danger found in not knowing how to stop moments before a work falls into a widely shared idea of "beauty" with the aim of reaching a consensus. In other words, just as one cannot look

for beauty for the sake of beauty, one cannot look for disgust for the sake of disgust. Mapplethorpe and Serrano demonstrate how, embedded in form, disgust and beauty in language and in other expressive means cancel one other out within a work. This sort of awareness can only be granted to someone like Danto, who is closely acquainted with artists and has acquired their way of thinking and operating. This, along with the fact that he himself was an artist before becoming a philosopher and an art critic, allowed him to become one of the most insightful interpreters of art of our time. It is his singular way of perceiving art that has made Danto both a beloved writer among artists and art critics, as well as a source of discussion and, in many cases, contention—a testament of the importance of his ideas to those within the realm of art theory.

Much like Danto, I have argued that pluralism in art manifests itself not only through the compresence of artistic paths that espouse different languages and experiences, but also in individual artworks. In contrast to the formalism theorized by Greenberg in the 1940s, and later in the 1970s, beginning in the 1980s many figurative artists incorporated methods and expressions of abstract art in their works. Likewise, many abstract artists welcomed narratives that, up until a few decades earlier, were the exclusive prerogatives of figurative art.

Scully, for instance, does not consider his paintings to be abstract: "Because they are not the abstraction of something that already exists." His paintings are composed of "seemingly truncated fields, equipped with different personalities and yet put together in an association that is open to a plural interpretation." Scully defines his paintings as "real," explaining that "in my work I always follow reality," which "derives from the visual language that I am constantly surrounded by in the city."[17] "In my view," he clarifies, "it is absolutely essential that we make art that is urban since it is always in the most extreme urban situations that human nature collides with consequences. This is why I am trying to subvert and humanize the relentless repetition of these forms through a reinterpretation and a subjective intervention."[18]

Danto explains that what was once traditionally considered to be an aesthetic experience has been transformed into a search for the truths that are hidden within works of art—truths that can only be perceived by way of interpretation. In other words, according to Danto, interpretation must have an object that cannot be infinitely deconstructed. Otherwise, in the whirlwind of interpretating interpretations, the object of interpretation itself fades and we inevitably distance ourselves from it. When referring to deconstruction, Danto states, "I'm pretty sure most of it has to be false, that is to say,

the idea of interpretation being endless, there being no such thing as truth. I think interpretation is fine, and there had better be something like truth."[19] Even so, it must be added that analysis generates one or multiple correct interpretations. Yet, however correct an interpretation may be, it is unlikely for it to exclude another and, in the case of an artwork, it cannot prescind from the motivations of its author.

In his book *The Transfiguration of the Commonplace*, Danto analyzes interpretive errors that may derive from a failure to know intentions behind a painting or sculpture.[20] Danto turns his attention to *The Fall of Icarus* by Peter Bruegel (ca. 1558), a painting that appears to depict an ordinary sun-drenched workday, both in the fields and at sea. The scene is captured from a point that is slightly upstream from the figure in the foreground. A peasant plows the land with the help of a horse; below, a shepherd and his dog keep a close watch on the grazing sheep, and, at sea level, a man is fishing. Sailing on the sea are various vessels. Near the vessel closest to the observer, a pair of legs can be discerned, splashing in the water.

Someone who is convinced that a work "speaks for itself"—that no specific information is needed to grasp its narrative and meaning—and has not yet read this painting's title may not notice Icarus's legs in the bottom

right-hand corner. They could mistake the painting for a simple landscape. The meaning of the work changes significantly once the legs protruding from the water are identified. Once they are related to the narrative, which is made explicit through the title, Icarus's legs become the focal point of the composition. As a consequence, other elements of the painting contribute to defining its narrative. The sun, for instance, suggests the cause of Icarus's fall, having melted the beeswax that secured the feathers of his wings. What Danto tells us when he explains the erroneous interpretations that might arise from a superficial observation of this work—and others like it—is that the interpretation of a painting or a sculpture from the past cannot exclude the intentions of the artist, who is capable of planting in the smallest detail the main element around which the entire narrative rotates. A proper interpretation is influenced by the modalities of representation related to the historical and geographic standing of the artist. An accurate interpretation, therefore, cannot abstain from placing a work within its historical context, or considering the modalities of representation, all while keeping in mind that "if it is an artwork, there is no neutral way of seeing it; or, to see it neutrally is not to see it as an artwork."[21]

Danto offers us another example. Let's imagine that a library of science has commissioned two paintings that

will be compared upon their completion. Let's assume that the artists are asked to depict the first and third laws of motion delineated in Newton's *Principia*. While they work, the artists—who have two different visions of art—keep every detail of their individual processes hidden. Danto hypothesizes that the two artists will put forth artworks that are formally identical, which he represents with two rectangles divided through the center by a horizontal line. Danto focuses on the motivations that underlie the geometrical figures in order to show that, while they are visually indiscernible, the two are profoundly different. This approach reveals that Danto's analysis of art is anchored in the fact that each work is a world of its own—each is a bearer of its own truth, and, while it may be different from the truth expressed by others, it has a legitimate right to be taken into consideration. For example, the truths that we recognize in Renaissance art today do not necessarily coincide with the truths attributed to it by people living in the fifteenth or seventeenth centuries.

No contemporary artist whose work I have studied is of the idea that art can express an objective, universally recognizable, truth. This objective, true of nineteenth-century painting, vanishes with the advent of the modalities of modernism and postmodernism. The worldview expressed in a work is always the product of the artist's

personal visions. The claim that an artwork expresses an objective truth is a chimera, as demonstrated by the fact that even the main players of minimalism, who believed they could express objectivity through works made with industrial material——in which the hand of man was not to be perceived—always took note of the differences between one artist and another, drawing a connection between their works and critical-philosophical theories and explanations of nature.

Even nineteenth-century realist painting was unable to achieve its goal of portraying something that could reach beyond the impressions of the artist, despite entrusting the truths of the visible world to the certainties of ideology. The truths we recognize today in the works of artists such as Gustave Courbet, Jean-François Millet, Giovanni Segantini, Honoré Daumier, Vincenzo Gemito, and Antonio Mancini are not to be searched for in the portrayed narrative, but in their ability to convey light and in the portrayal of reality, which photography would soon present as a poetic transposition of reality itself. In the face of reality we are but spectators. Every time we speak of it in objective terms, I believe we betray it insofar as we conceptualize it, and we place it within a context of reasoning. And yet there is no other way of approaching it. This matter is not extraneous to art: art cannot illustrate reality by presenting it as an

expression of truth. Truth belongs to theory, which, in turn, determines the nature and the narrative of the work.

But how much truth is in the things we see? We might say that there is nothing truer than what we see; yet, when captured by art, that same truth stops being what we saw and becomes something else. In Anselm Kiefer's portrayal of a burnt field, there is so much more than what we recognize: there is the desolation of a key moment in German history. In the reflective steel sculptures of Anish Kapoor, with their twisted shapes and eye-eluding boundaries, lies the three-dimensional representation of just how deceiving the perception of a solid body can be. Art tells us that what we see is not true in an absolute sense, but only through the meaning we comparatively ascribe to it in relation to something similar, or in relation to history—or, better yet, through our personal experience. Truth escapes us, yet, in our search for it, we must act as if it exists.

Certainly, as Danto tell us, a work of art reveals much more than what our perception can explain. Art always adds something to what the artist includes in his work, further complicating the interpretation of it. At the same time, there is much more to an artwork than what an analytical comparison can reveal. This in no way diminishes the validity of the method adopted by Danto: a

work is a source of information, whose meaning cannot be fully grasped, due to its complexity, without a method to guide us through our understanding of it. The fact that different methods can lead to different interpretations is an entirely separate matter. Unless, of course, we answer one question with another—in which case, the discussion continues.

Danto did not claim to have a categorical response for the works of art he analyzed. His methodology was rooted in the idea that, through a comparison of and focus on certain clues, a work would unveil its own meaning. Be that as it may, criticism must always take into account the motivations of the artist lest it risk betraying the meaning embodied by the artwork. Danto's criticism of the abuse of hermeneutics went hand in hand with his conviction that it is within the labyrinth of interpretations that the crux of an artwork can disintegrate.

Arthur C. Danto, New York, 2010. Photo Luca Del Baldo.

Arthur C. Danto, New York, 2010. Photo Luca Del Baldo.

Sean Scully, Arthur C. Danto, and Demetrio Paparoni at the John
Good Gallery, New York, for *La metafisica della Luce*, curated by
Demetrio Paparoni, November 1991. Behind them: Sean Scully,
Catherine, 1989. Photo Allan Finkelman. Courtesy John Good.

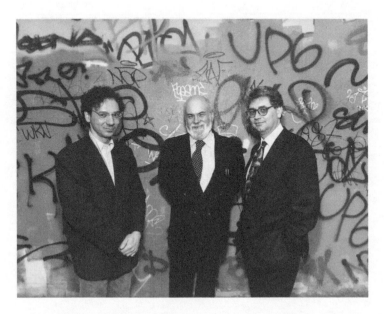

Peter Halley, Arthur C. Danto, and Demetrio Paparoni, New York,
November 1991. Photo Kevin Clarke.

Arthur C. Danto and Demetrio Paparoni correcting the drafts of
their conversations at Danto's home in New York, May 29, 2012.
Photo Barbara Westman.

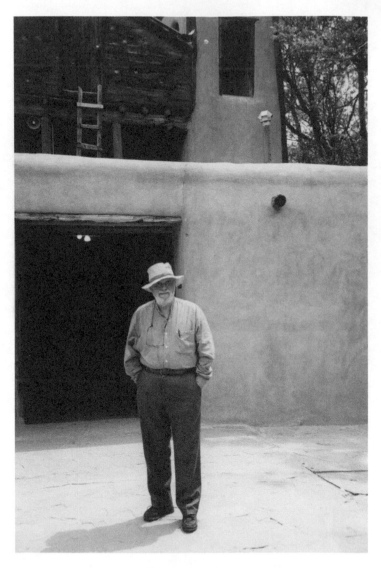

Arhur C. Danto, northern New Mexico, June 1999. Photo David Reed.

ART AND POSTHISTORY

ART AND POSTHISTORY

1

HISTORY AND POSTHISTORY
(1995)

DEMETRIO PAPARONI: Unresolved questions are revealed when one claims to understand what leads an artist to think or intuit a formal balance within the confines of the canvas. What is certain is that the seriousness of the canvas contrasts with the lightness of thought, of intuition, and that the impact of this lightness on the white surface of the canvas requires a lot of energy. It's no accident that many painters have described the moment of creation like experiencing full-body contact with the virgin canvas. What pushes the artist to choose to create a small or large painting? There is a large canvas behind us; on the table in front of us there is a small-scale scroll. The two works have the same intensity, independent of their size.

ARTHUR C. DANTO: Personally, I prefer smaller works because they are more concentrated. Often, when the space is too big there is a loss of meaning, of energy. Smaller paintings communicate a strong energy. I think it must be ten times more difficult for an artist to make a painting two sizes bigger because of all the empty space to organize. It's not always successful. Take Motherwell, for example; his small works—drawings and paintings—are much more powerful, they are more intense than the large ones, which instead seem dispersive, devoid of energy. I think that for everyone there is a natural size to work with: it can be the size, the use of the arm, or the use of the wrist. For example, you, Mimmo, to paint this scroll you worked on a table. This also makes a difference: all of the weight of your body is put on your hand. I believe that the way in which the body engages with space can be quite telling. But all this has not yet been well understood.

DP: Of course, dominating a large canvas or a small-scale piece is not the same thing. Do you prefer painting a small work? Or do you find yourself more comfortable with large surfaces?

MIMMO PALADINO: I don't agree with Arthur on this. Sometimes it's much harder to control a smaller surface than a larger one. Controlling the details within a confined space is as difficult as dominating the light on a vast surface. At the same time, however, there is a naturalness of doing. A painting is like a breath: its creation is equivalent to taking a stroll.

ACD: That's probably true, but there is always a difference between what you see when you walk and what you see when you stop and focus, when you hold something in your hand, and look at it. Walking, your eyes move, there is an inevitable dispersion of your perceptive field. When, instead, a person stands still in one place and his whole body is struck by something in particular, then the reflexes that are stimulated are very different. I am sure that working on a large-scale canvas requires a lot of energy; it must be exhausting.

MP: When small works are created your thought flows and your hand doesn't need much energy. When one deals, instead, with a large canvas the thought must be tamed, so more energy is required. I call my

smaller works "icons," because when I make them I feel as if I am a monk standing in front of a painting table: it's like a spiritual exercise.

DP: But icons are impersonal paintings, while your painting refers to a universe and a style that, as you yourself have declared, belong to you.

MP: You're right. As I told you before, I only call my small works icons: they require a lot of thought, a lot of intellect. Contrastingly, in a large painting the intellectual control almost escapes and you need more vital energy.

DP: Arthur, in your recent conference at the Brera Academy you spoke at length about Warhol. I think that his silkscreen works have a certain connection to the production of icons, in that the technique he used inevitably leads to an impersonal style.

ACD: In the Eastern Church the icons are a very important presence. In Pittsburgh, where Warhol grew up, I visited the church that he attended as a child. So there were icons there that Warhol had seen as a child. What is interesting to ask is not who painted the image or when it was conceived, but if it can

make miracles. The icon is like an open space in which the Virgin and Christ will enter when they hear our prayer, our call for help. The artist exists only to make that haven possible: a sacred gift in the church. One cannot know which icons are inhabited by the Virgin or by a saint, and which aren't. Even the icon made in a factory, when put in the church and adored, can accept the presence of the Virgin, and can become a gift. This is the value of the icon: to make possible something that cannot happen in any other way. We find ourselves in a space transformed by the icons; suddenly we are in the same space as the sacred presence, and it is very different from the external space. Then you can look at the icon and say: "It was painted in 1893 by so and so . . .," but these dates are of no importance. So you're right when you talk about impersonality. But this is a special impersonality that substantializes the relationship that exists between the image and its observer. This relationship is different than the one that one has before a work of art: it is more charged with energy, it is charged with all the problems the person carries with him when he stands before a sacred image. Making an icon is a very powerful idea, because you ask an icon things that you could never ask a work of art. Even if we changed

5

our relationship with the icon, we have become simple spectators before it; this is not the same as seeing an exhibit in a gallery. It's as if you are in the presence of something that belongs to another space.

DP: Two weeks ago, standing before one of Mimmo's ceramic sculptures, I thought that, if in twenty years someone were to show it to me, I would say that it isn't his. I didn't recognize his hand in it. Mimmo himself only created the sketch, then he entrusted an artisan to execute the work. I don't really understand this choice well, because I maintain that in this case the tactile sensitivity of the artist plays a fundamental role in the creation of the work. In Sol LeWitt's sculpture this is not the case; what actually counts is the project, while the creation, dictated by precise plans, can be entrusted to one or another assistant. I don't think that this, however, can be true for an artist like Paladino.

MP: The choice of material for the sculpture you're alluding to is important. I was, in fact, inspired by the ceramic statues of the traditional Italian gardens. In this case I limited myself to producing an idea, a poetic image. Then it was essential that an artisan, a monk, create the work. That's why the sculpture

seems impersonal. Already during the eighties, I avoided any excess of expressionism in my painting because I tended to give my works an impersonal dimension. I have always kept the lesson of conceptualism in mind, I didn't want to run the risk of attaining expressionist results. The concept in itself is not, however, enough to justify the work. When I conceive of a work that has a complexity that is different than what emerges from its design, I turn to nonexpressivity, because it allows me to distance myself from the work so that I can control it better. In evaluating art from the eighties onward, one must keep the great lessons of Duchamp and minimalism in mind. The art of the eighties is not fractured from what came before, it isn't avant-garde because it is tied to what preceded it and to what it stems from without a desire for rupture.

DP: It steps away from the logic that characterized the avant-garde. Despite the fact that your work distances itself from the frenetic behaviors of the avant-garde movements, in it there isn't any pacification of the form within the style. The sign, the brushstroke, they are recognizable, yet what pervades is an unsettling that manifests in the constant attempt to break the attained balance. In this

sense, while we are talking about structured painting, there is an unexpectedness of the brushstroke that at times has made me think of the unpredictability of the Action Painting painters.

ACD: A few days ago, in New York, I saw Franz Kline's beautiful exposition. In it I noted two kinds of expressivity: the one of drawings and the one of paintings. The journey from the study to the drawing and from the drawing to the painting is an almost mechanical process: Kline even uses a projector. Isn't that fascinating? I read Richard Diebenkorn's account, he visited the artist's studio in 1952 or '53. He says that he was shocked when he saw him work like an ancient master. Now a different kind of expressivity is beginning to emerge, one that has nothing to do with Kline's. His expressivity is more complicated; it isn't easily comprehended. It has to do with the relationship between the white and the black instead of the interaction between the artist and the canvas. I was very struck by Kline's drawings. He made them on a phone book, very clean and fresh. There are no drippings, because to make them he had to keep the work upright. If there is the intervention and mediation of a mechanical

8

process, and this process consists in entrusting someone else with the task of animating or coloring the drawing that was done by the artist—the personal touch is of no importance.

MP: The most important thing is that the artist is allowed complete expressive freedom. The drawing is considered an autonomous work and not a project. There are many possible methods for working, not just one. This is, probably, the philosophical sense behind my approach.

ACD: The essential drawing, the essential form that is used, is never an open road. Open forms are possible when the artist puts some drops of black paint on the canvas that then rivulet downward. At times Kline paints over these drippings, so that they are almost entirely hidden, just barely perceptible. In some cases he adds black, and the black is superimposed onto the white: this is about painting though, not form. For years we took Kline's work for granted, we all thought we understood what he was doing. Visiting this show was fundamental for me, it allowed me to understand how Kline worked. His method is very different than the one that is

used by the abstract expressionists. We believed that Kline's work consisted in a series of brush-strokes: one black and one white . . . and nothing else! But nothing could be more wrong.

MP: Understanding Kline's paintings as a series of black and white brushstrokes leads one to a warped and romanticized vision of his work.

ACD: I think that in the eighties many got lost; they lost their way. The French call it "trail" or "path." I think that many German artists lost their path—it was all too personal—they lost sight of reality. They only used color for expressive ends, without considering that it has a life of its own. I never liked this kind of expressionism from the eighties.

DP: Arthur wrote that the end of history coincides with the end of narration. Does your painting possess a narrative dimension?

MP: My painting has no narrative dimension whatsoever!

DP: Yet in many of your paintings there are subjects that are rich with memory . . .

MP: In appearance. In reality I refuse the interpretation of my work as archaic memory. That's why I feel close to Motherwell's vision, he believed that the concept coincides with the spirituality of being an artist: the language prevails over the narration. This is the spirit with which I created a series of works on Joyce's *Ulysses*: it is true that I am fascinated by the idea of the journey, of the labyrinth, of the stop-over, of time that passes, but it is also true that my interest is focused on language, which is more important to me than the poetic subject. This is why I collected various editions of *Ulysses* that I intervene in by drawing on them. This is why I work on books published in different languages. I would like to find one in Arabic and one in Chinese. The language becomes a sign that goes beyond the narration.

ACD: In some cases Kline is a narrative painter, or he says something, he makes a declaration; he isn't just formal. Neither is Motherwell. I know Motherwell fairly well. I think that his elegies for the Spanish republic are political works. They focus on political suffering and political hope. They are works that speak of death. I don't think that Kline had these kinds of questions in mind; if anything

he referenced more personal situations—his wife was crazy, she was committed to a mental health facility. In one of Kline's drawings from 1946 he drew her in a rocking chair with her head bent over her body. It is a very essential image. Behind the woman there is a form similar to the black ones present in his larger abstract works. The drawing is so concise that if you removed six or seven lines with white varnish you would get a real and true abstraction. It's a powerful piece! Those black shapes seem like barred windows, and this creates a very powerful metaphor. As a matter of fact, in that painting all of this becomes reality, while in abstractions it becomes a metaphor. Rembrandt comes to mind, his paintings that portray his dying wife, a reality immersed in a very expressive black. I'm thinking particularly of one of his splendid drawings from 1636, in which the face of a woman is magnificently drawn, it seems almost like standing before one of Kline's drawings. Kline always referred to his personal reality, to a story, to something that, in a certain sense, was narrative. In 1960 he came to Italy, where he made some beautiful paintings. In particular he created one, *Black Sienna*, where it's impossible not to see a large black horse. He died the next year, he was still young,

about sixty. This year in New York there were many occasions to see the works of the abstract expressionists: de Kooning, Kline, Newman, Motherwell . . . We have returned to the fifties. I found this return to be quite exciting.

DP: Yes, I get the same feeling when I listen to music from my adolescence. This shows the temporal connotation of our existential experiences. This does not imply that the object of art is not capable of escaping time, of holding absolute value. Tolstoy said that art communicates a feeling to all men, of the present and of the future. Those words express a trust in what's to come. Mimmo, do you recognize yourself within theories about the end of history?

MP: On a personal, existential level, I share them, even if it's inevitable to think that the work of art will persist through time.

DP: The idea of the end of history is in some way tied to the awareness of the transience of the individual.

ACD: Yes, there must be a causal connection, even if I don't really understand how it is created. I spoke of narrative paths that are carried out through human

actions and, in this particular case, through the actions of the artists. Things happen in a certain sequence that, a posteriori, seems inevitable. There is a history that is carried out, and part of history is also to reach the end. In some way it is necessary that there is an ending. What will happen to art then, I don't know.

DP: Of course, the end of history is not the end of art. But nevertheless art is history, so if history dies then so must art.

ACD: I was talking about the end of a history, not of the death of art. For a while we have been living in a world structured by history. Now we are headed toward what I call "posthistory." We have no more stories. People do not give up because the human mind always wants to see things from a narrative perspective. But sooner or later we can defeat this thirst for stories and look at things as they are.

DP: Perhaps history coincides with a narration of artistic doing.

ACD: Perhaps. I believe that the concept is too reductive, however. I'm thinking of the great narratives:

Vassari's, which begins in 1440 and lasts until 1880, and Greenberg's, which goes from 1880 to 1960— one passes from painting as a representation to painting as an object. This is modernism: painting becomes an object. And within this process there are smaller stories to tell. The artists asked themselves: "Why must I be forced to painting an object? If it's about painting objects, then can one return to representation?" The answer was that instead of returning to representation it was better to abandon art completely. I don't think that after this narrative another exists; there is a point in which narration ends. When you reach that philosophical moment, what happened also begins to become clear and at that point art can go in whatever direction.

DP: *Tema Celeste* recently published a conversation between Mimmo, Peter Halley, Jim Dine, and other artists. To tell the truth it wasn't a dialogue that occurred around a table; we had a conversation via fax. Peter affirmed that, in New York, people don't die, they disappear, and so it's anachronistic to talk about death. Mimmo doesn't think like Peter does.

MP: I maintain that death is surpassed in the funereal rights that are celebrated by the living. In the South

[of Italy], for example, a strong spirituality accompanies the procession of the hearse. This means that the story of that man doesn't end with his death, but it continues in the memory of him, in the traces he left behind. Even the most anonymous of existences leaves a trace, a memory: if an individual dies, nothing disappears. In this sense I believe that history never ends and that art can't end with history.

ACD: In English, certain stories for children, stories about fairies, are called "fairy tales." The ending is always "and they lived happily ever after." At the end of the tale the handsome prince arrives, kisses Snow White, brings her back to life, and marries her. End of story. The film ends, but life goes on. This is the model I am referring to. Marx had this idea, he thought that, if the contradictions were resolved, history would come to an end. From a certain moment onward this was his brilliant idea: men are no longer molded by history, but by themselves—as Hegel would say as well—they create their own. In the great philosophy, in Hegel, there is the idea of history as the story of liberty. When the moment arrives in which the idea of freedom is reawakened in everyone, then everyone is free and begins to

build his or her own life. In that instant history ends, but life continues.

DP: What is beauty in this kind of context? Does beauty die with history's end?

MP: I don't think that beauty can end with history.

DP: But if history really ended, our condition with respect to the world would change, and so our conception of beauty would as well.

MP: The concept of beauty has always changed through history. This is clear. I believe that the concept of beauty can be architectonically built around history, but undoubtedly it is moved by feelings that are deeper, feelings that everyone possesses. If man as a biological entity, and as an imaginative entity, does not disappear, the idea of beauty cannot disappear either.

ACD: I am not convinced that beauty is an historic concept, because beauty is not limited solely to art. There are beautiful lives, beautiful things, beautiful moments. We all have the same idea of beauty, even

if each one of us perceives things differently based on the different factors of his or her formation. A few days ago I had a conference in Zurich about a passage taken from John Ruskin. The English art critic had gone to Turin, where there was a painting by Veronese. There, while he was making a copy of the Veronese painting, he heard a religious sermon on the poverty of the human life, on the misery of human beings, on the emptiness of our existence. Hearing phrases like "To avoid destruction we must follow God," Ruskin looked at the painting and thought that, if the priest was right, then Veronese was wrong, because he made the world look like a marvelous place. Does God really want us not to look at beautiful women, or beautiful men, or beautiful things? Is Veronese therefore on the devil's side? No. He reveals something extraordinary, but experiences of this kind have great value only for people like Ruskin, who continued to paint, day in and day out, thinking of that painting, of the need to change his life first, and of the opportunity to then leave it be: this is the right way to live in such a beautiful world.

DP: Look at this small scroll painting: Where does its beauty lie?

ACD: What is very beautiful about this painting is the fact that it is created on a golden background. It's a miniature. The gold already possesses two characteristics of artistic beauty: luminosity and preciousness. This work is small, but sublime.

DP: We are moving within classical categories. Let's shift our attention to something else: What is beauty in relation to a Donald Judd sculpture?

ACD: It is mathematics, conceptualism; it is the beauty of intelligence, of repetition.

DP: Charles Baudelaire comes to mind, he advised that "because beauty always contains an element of wonder, it would be absurd to assume that what is wonderful is always beautiful." The fact remains, however, that independent of the ability of an object to amaze, today more than ever it is possible to conceive of differing ideas of beauty.

ACD: Of course!

DP: Was this the same in the past?

ACD: Why must there be just one idea of beauty? It would be interesting, from a philosophical point of

view, to take all of these different conceptions of beauty and see if it is possible to find a common reference point. But I doubt it.

MP: In the work of these last few years we find the beauty in mathematics, in hysteria, in drama, even the beauty in geometry. So, for the last ten years, or maybe more, the time of the avant-gardes, who proposed just one model of beauty or refused to propose one, has ended. At the end of this moment in history varying conceptions of beauty emerged.

DP: Is Duchamp's bicycle wheel beautiful?

MP: Today it could assume a new form of beauty.

ACD: I don't know if it was or if it is beautiful. One can say that it was, but I don't know if the work consists simply of the bicycle wheel. Perhaps in Duchamp's case it could be that his readymade has some elements of beauty, but the artist, referencing Masaccio's *The Expulsion from the Garden of Eden*, was interested in the "expulsion of the beautiful." His aim was to eliminate beauty; the object was not supposed to be beautiful. Duchamp was very much

contrary when he realized that people found his objects beautiful, particularly his *Bottle Rack*. The problem is complicated because the object—the way of perceiving it—is complex.

MP: The bicycle wheel is beautiful because it has the beauty of a symbol.

DP: Your opinion coincides with Bacon's; he maintained that Duchamp was figurative in that he transformed each figure into a symbol. Bacon thought that with his objects Duchamp was making a shorthand of representation, thus giving life to a kind of twentieth century myth. I find it curious because both you and Bacon, starting from a shared painting experience, arrive at the same conclusion. You are both animated by the conviction that the concept of appearance is radically called into question, since the accident can transform the nature of what appears. A more or less chance brushstroke can thus burst on the scene with such intensity that it makes the work absolutely original. But you, like Bacon, are a painter, while Duchamp had renounced painting: Duchamp searched for indifference, he showed objects that left him indifferent.

MP: But the historical distance between the object and us creates the necessary condition for the wheel to become symbolic beauty. It is inevitable. Even Manzoni's tins, in the end, assume, to his dismay, an idea of beauty.

ACD: This morning I visited the Brera art gallery, where I saw, among other things, some of Medaro Rosso's sculptures. It is clear that he wanted to create beauty. But he worked with wax, and wax is dirty. Unlike what Duchamp—who didn't want to create beauty—did, yet now his objects start to seem beautiful.

DP: It is the beauty of choice: to exhibit something that isn't a painting or a sculpture in the traditional sense. What is the difference between painting and sculpture? It is certainly the case that with a sculptural mass we no longer find ourselves before something tamed. Individuating the differences isn't easy, because with modernism all the techniques mix in some way.

MP: In Giacometti this wasn't a problem. There was instead the need for sculpture to assume a meaning in the emptiness of our existentiality. On the

other hand, the painting/sculpture juxtaposition had already dissolved with the avant-gardes: the object entered the painting, the painting portrayed the object and, with Picasso, the artist painted the sculpture.

2

STYLE, NARRATION, AND POSTHISTORY
(1998)

DEMETRIO PAPARONI: You have theorized that, since the sixties, the end of the narrative structure and the acquisition of an increasing self-awareness within artwork has delegitimized art, making it often cross into philosophy. The end of narratives coincides, for you, with the end of history, and so the artist works in posthistory. What happens to style in a scenario like this?

ARTHUR C. DANTO: Art is always a legitimate human activity, but for a long time ideologies—I'm thinking mostly of Marxist critics—would denounce some works that were considered counter to the revolutionary spirit. I had the chance to reflect, mostly on the great narrations that have defined criticism up until recently (the narrative of progress, of

modernism, of philosophy, of Marxist history) in which legitimacy and narrative were intrinsically tied. The weakening of these narratives was accompanied by the weakening of this kind of delegitimization. The fact that artists did philosophy does not represent, in my opinion, a "digression." Through the intrinsic development of art, a true form of the philosophical question about the nature of art emerged—that is to say, why is an object (like the Brillo Box, for example) a work of art, while another object that is absolutely identical to the first from a perceptual perspective (for example, a box of Brillo) is not? I thought that this only had to do with Warhol, but the same question was raised about all of art more or less at the same time (1965). I would prefer to say, then, that at a given moment, art as a collective endeavor, through its internal development, led to an awareness of the philosophical question. The answer could have come only from philosophy, but since the question became responsive, there was space for artists to also attempt to respond, and consequently they behaved like philosophers.

Once the narrative ends, there is no longer a privileged historical direction. This corresponds to an extreme pluralism that is typical of the posthistorical phase of art. But, at this level of separation,

can something exist that is equivalent to style? I think this is truly a difficult question; just think of the problems raised by the art of appropriation. Think of Mike Bidlo or Sherrie Levine: every style is at the artists' disposal the moment in which they decide to make use of it. Melissa Meyer, for example, uses forms of abstract expressionism. But everyone can do what he or she wants. You could even draw from Piero della Francesca! However, it would be very strange if there were no kind of late twentieth-century style: this style is probably invisible to us now, but it will become visible as soon as it has passed. I mean to say that we live in a precise historic moment, and being in history means betraying our historicity in the eyes of the future. The way in which we live today will be accessible—as history and not as life—to those for which our style will become visible. This has nothing to do with narrative, not more than in the case of individual styles. Anyone can recognize the works of David Reed, Jonathan Lasker, Sean Scully. But what style do they embody? When we have that answer the present will be the historic past!

DP: I don't want to seem banal in affirming that the end of an era should coincide with the beginning of a

new one. Yet we know that the end of the Enlightenment coexists with a pre-Romantic climate and that at the end of the great Romantic and realistic cycle of the 1800s the great adventure of the twentieth century avant-garde began. From the end of the seventies, with the fall of ideologies, every model of avant-garde intransigence should have waned. Yet we find ourselves before a late avant-garde revival as well as its realistic equivalent. Artists like Matthew Barney (who, with his mythical references, works in a behavioral direction), Nan Goldin (who documents gory fragments of her own life), or Andres Serrano (who turns realism necrophiliac) would seem to be evidence not only of a resurgence of narrativity, but also of the will to free art from linguistic self-analysis. And this is in favor of a realistic structure that, paradoxically, finds inspirational sources in the language of the avant-gardes. It's no accident that the work of these artists gets legitimated through shows in galleries that are usually known for their progressive choices. It seems to me, therefore, that the dynamics that legitimize a photo as a work of art are not that different from the ones that the Dadaists used when they exhibited their "found objects" in gallery spaces. Now, while the Dadaists theorized an aesthetic of indifference

that negated the idea of style, you can't say the same for the artists I just cited, who affirm a distinct and personal aesthetic worth for their images. It's no accident—each time we recognize the work of an artist at a glance, it seems clear that the work expresses an idea of style. Do we therefore find ourselves having to joust with different definitions of style? One for those that tend toward pure language (like Ryman or Marden), one for the artists that objectively document a situation—and thus narrate a story (Goldin, Serrano), one for those that find the instruments of analysis necessary to express a new form of spirituality within society (Scully, Halley, Bleckner), and so on?

ACD: I agree with what you're saying. Part of what make Goldin and Serrano avant-gardists is their subject— sexuality of genre in the first case, and dead human flesh in the second—in addition to the use of large cibachromes rich with color. Thus one witnesses the bestowing of beauty onto a subject that is positioned at the limits of social acceptability. The artistic tolerance of an open art world, within a society that is much less open and permissive, makes these works avant-gardist—certainly not the fact that they are shown in a gallery. The closed nature of moral

imagination, however, works through delegitimization in a period in which everything is allowable in structural terms. I find the clear-cut distinction between documenting a situation and stating a new form of spirituality to be a bit disconcerting: it seems like it defines the difference between representation and abstraction too simply. I don't see why one can't maintain that Goldin and Serrano are expressing a new form of spirituality: they are both deeply moral artists. But Scully and Bleckner are as well. Morality, however, always implies a descriptive truth: what would Bleckner's works mean if AIDS never existed or if he wasn't connected to homosexuality? All of these artists make use of a series of visual metaphors tied to those realities. In each case, what is of interest is the way in which the opening of the artistic world allows them to respond to serious human questions, and not just to the imperatives of art.

MARIO PERNIOLA: It seems like Danto is shedding light on a problem of extreme interest, the problem of the visibility of the present. We do not see, and so we don't know, what we live. Life is not something whose meaning can be immediately gaged. Natural and empiric life escapes us constantly.

Living is none other than a continual disappearing. This involves certain consequences. Firstly, the rejection of the poetics of naturalism, which since last century has affirmed the identity between art and life. There is a naïve assumption at the root of naturalism: the vitalistic idea that identifies the immediacy of experience with its truth. Happening, performance, and live art today pursue an absurd objective. Secondly, how do we get out of this situation? The German philosopher Dilthey thought that what was essential was not living, but reliving; not the immediate experience, but the lived experience—or, rather, the relived experience. According to him, the highest form of understanding is not the living but the reliving: only through this can we separate the present from its disappearance and transform it into an always-available presence. This is the job of poets, of historians, and of philosophers: separating the human world from death and its transience by giving it a meaning forever. But do we still have the trust that Dilthey had in this historiographical work? Danto rightfully doubts it. Must we then resign ourselves to skepticism? Is it possible to find a third path that surpasses both ideology and skepticism? It seems like Danto's thought heads toward the search for this

third path. Here is where the notion of "style" intervenes, a notion that refers to the notion of forms—namely, to a dimension that is no longer temporal but structural. Danto recalls one of the great aesthetic problems of the 1900s: the conflict between the "friends of life" and the "friends of form." On the one hand there is the idea of aesthetic experience as empathy, vital experience, immediacy, while on the other hand there is the idea of aesthetic experience as form, art's will, style. So, in other words, do we have the avant-garde on one side and classicism on the other?

ACD: When Perniola speaks of the "visibility of the present" he raises two interesting topics. The first has to do with descriptions of the present, which are cognitively inaccessible to those who live in it. Imagine someone who looks at Manet's *Déjeuner sur l'herbe* (*The Luncheon on the Grass*) at the Salon des Refusés in 1863; that person is surely capable of describing the painting: two naked women, two dressed men, outside, green grass, etc. If the viewer is a scholar, he will be able to see a reference to Raimondi's famous engraving *The Judgment of Paris*. Innumerable true positions exist that, based on the viewer's observation, can be formulated about the

painting; the observer could, however, not know that it was the first painting of the modern age, he could not know that in painting a painting of the like Manet became the first modernist. He simply cannot have the concept of modernism available to him in 1863: he cannot understand that the painting is the start of the narrative that, a century later, in 1963, Clement Greenberg will talk about in his essay "Modernist Painting." What makes the present invisible is the invisibility of the future. Michael Fried recently tried to show how difficult it is to see Manet as his contemporaries saw him. Manet's work was inevitably valorized—some of his ties with impressionism, for example, and from the tendency to read him in light of Monet or Sisley's work. To see Manet through the eyes of his times one would have to strip his awareness clean of everything that, from this point of view, could be considered historic contamination. Perniola makes a kind of aesthetic corollary from these considerations, and he juxtaposes it with the theories that assign a canonical foundation to the immediacy of artistic experience: the belief that art must be experienced with the immediacy of a punch in the stomach. Many have maintained and still maintain that opinion. I recently read an interview with David Sylvester, and he

lamented the fact that art is having increasingly less of an impact on him; it disappears through time, just like sexual desire. Probably art itself has changed— after Duchamp, in fact, it's no longer optical, it's intellectual.

DP: Danto's idea that the work of art is not a stable identity but something that is also dependent on its historical reception is striking to me. It seems like a very important idea because it draws attention to an aspect of aesthetics that has been largely neglected. Aesthetic attention has, in fact, all too often centered on the completed and perfect nature of the work of art.

From Danto's perspective, however, the work is never actually completed, because the perception, the historical-critical judgment and most of all the influence that it exerts on the production of other works can deeply change its meaning. So the notion of "influence" emerges as a central idea. From this perspective, Danto's thought is part of that twentieth century aesthetic orientation that is particularly aware of the relationship between art and action— namely, the orientation that sees the essential of aesthetic experience not as something *essentially*

theoretical (like in Croce, in phenomenology, in hermeneutics, in philosophy, and in symbolic forms), but as something *essentially* practical (like in John Dewey and, in another way, in Ernst Bloch).

ACD: I appreciate the thesis that Perniola is proposing, according to which the perception of the work as an "unstable object" is connected to a vaster philosophical perspective: everything that exists in history is equally *unstable*, unless it possesses a human meaning that goes beyond the meaning that it possessed the moment it was brought into being. I mean to say that some events assume meanings that are very different from the ones that they could have had when they were created, in virtue of the relationships they have with events later on.

DP: In a society that is becoming more and more abstract and is inclined to virtually live out many experiences that were once thought of as impersonal and social, the concept of style, instead of expressing the artist's intention, could point to the impersonal structure of the society that the artist finds himself in. What relationship can we establish today between style and personal creativity?

ACD: I don't think I know how to answer that. It's unlikely that *intention* disappears, but there are problems expressing it when it approaches phenomena like cyberspace. Drawings can't express the artist's touch they way they used to with a pen or paintbrush. However, there are other sources of support for intention, like in the object being drawn and the reason why it is being drawn, for example. I don't know how the abstraction of society is embodied in a style, but I imagine that it could happen. It's true that our societies are very abstract, in the sense that we no longer live in hillside villages or in city-states, yet, through the media, like television, the state is very present, and the Internet is a part of the nature of the approaching global village. I believe that the historic style of the present—which is currently invisible—will be the one that is opening up and when this happens, it will probably have the flavor of the social reality you allude to.

DP: Style is also recognizability, in the sense that an object or a person is identifiable for its constant way of being and presenting itself. Joseph Beuys and Andy Warhol had a very precise idea of style that they manifest, aside from in their work, even in their way of dressing, of speaking, of moving. Today many

artists tend to break this linguistic uniformity, and it often happens that you go into a gallery to see a solo exhibition and you find yourself before works that are so different that you get the impression of being at a collective show. While this heterogeneity can lead to a singular project on a theoretical level, we find ourselves facing linguistic chaos. Art, like science, tends to analyze the mechanisms that regulate the world in a way that is as much intuitive as it is dependent on an idea of order: the theory of chaos is a meaningful example. One plus one equals two, but for biological mathematics a man plus a woman makes three, since they possess the potential to make another life. I think that artists that have adopted linguistic plurality within the same body of work will absolutely be penalized by the market, since the market requires an immediate recognizability of the object. In addition, the drive that animates an aesthetic of the kind—an aesthetic that is the enemy of style—is idealist when it opposes one of the strongest forms of psychological coercion an individual has ever been subjected to: commercial advertising. Advertising tends to unify the average tone, it tends to create a uniform taste and get dangerously close to a unified thought. So-called self-referential advertising, the one that publicizes

itself before it publicizes the product, which it is freed from, as an ideological message, represents the most tangible expression of the power of the media in the cybernetic age. The medium is no longer the message, as Marshall McLuhan said, because by now we have gotten used to it, it's too familiar. Today it's the message that takes advantage of the medium. In this sense advertising is less eclectic than it would like to appear, it has a very strong idea of style because the power of whoever sends the message must be completely recognizable. Up until a few years ago there was a big debate about subliminal advertising messages; today, instead, advertising affirms its effect under the pretenses of bettering society. So now the question is, in contrast to what happens with advertising, can exact correspondences between art and society be established?

MP: I don't think that exact correspondences can be established between art and society. Art lives an autonomous life independent of "life": it has its own history that can be only partially linked to political, social, or economic history. Kubler's theses seem very important in relation to this. He maintained that every human work is positioned, with more or less awareness, within formal sequences that span

centuries. Through this lens, their arrival has little to do with that confused and messy accumulation of events that is history in a purely chronological sense. Kubler thought through a philosophy of history that is not solely retrospective, as Dilthey's was; for him the history of art is always open, everything can become current again.

And now let's ask ourselves: Can realism become current again, and, if so, how? I think that the artists we have been speaking of constitute an example of what I would call "psychotic realism." I would define it as a tendency to identify with the real, to make oneself an extraneous body, to expel yourself from yourself and locate your organs and feelings in something external, become other. Art loses its spirituality and acquires a physicality and materiality that it never had before: music is sound; figurative art has a consistency that is visual, tactile, and conceptual; theater is action. These are no longer imitations of reality, but reality tout court, no longer mediated by aesthetic experience. The dramatic aspect of this process lies in the fact that this tendency to identify oneself with the external world constitutes one of the essential elements of psychosis: "I am fascinated by exteriority." I become what I see, feel, touch: the surfaces of my body identify

with the surfaces of the outside world. The Viennese artist Rudolf Schwarzkogler (1940–1969) is emblematic of this tendency. The chilling photographs of his actions have the same importance for art today that Duchamp's readymades had for the avant-garde.

DP: Many works are tied to the contingent, both on the existential and the social level. That's not why art has lost its spiritual dimension. Artists like Kapoor, Paladino, Bleckner, or Scully, and many others who apparently don't broach the metaphysical, make declaratively spiritual work. But even the works of artists who constantly reference societal observation, like Kounellis or Halley, express a not-indifferent spirituality. There are many other names that could be named. Even performers like Rudolf Schwarzkogler or Orlan have noted the need to confine their image to a frame, as a demonstration that their actions go well beyond the rituality of the gesture. Yet it's undeniable that, as Perniola says, we find ourselves before a kind of realism. Of course we do. This is evidenced by the fact that what I call "redefined abstraction" represents a form of realism, since it mirrors a society that has become more and more abstract.

ACD: There's a danger that computers, faxes, and modems will lead us to what Demetrio Paparoni calls the "abstraction" of modern society. I miss, for example, communication that is possible because of actual coexistence—looks, gestures, pauses. And abstraction dramatically increases if we go on the Internet; people hide under fake names, provide us with misleading descriptions, and things like this. But since we are made of flesh and feelings, society can never be completely abstract. In any case, I don't agree with Demetrio about the fact that abstract painting is realist because it depicts an abstract society. However, I am convinced that abstract paintings represent (not describe) different things. For example, talking to Sean Scully about his works, I am always amazed by the meanings that he wishes to communicate. These meanings are moral, emotional. They are far from abstract, even if the paintings are effectively abstract. If they are "spiritual," what do we mean by "spirituality"? Something religious? Something metaphysical? Or simply something that transcends physicality?

Since, in a certain sense, we have maintained a sociological approach, I feel like, in our contemporary Western society, there is the desire for something spiritual, and that art is considered a prime

candidate for this role. Religion itself is always more ritualistic, and consequently less and less spiritual. It's as if we live in a moment of transition just before what Hegel calls the "absolute spirit": from religion to art. The vehemence of fundamentalism all over the world is a sign, in a religious sense, of this event, and of its resistance. But art has two faces: it looks at religion in the sense that it responds, albeit inadequately, to the human need that was once answered by religion, and it looks at philosophy, for what it aspires to in the highest degree. Thus two roads of artistic spirituality exist: the one taken by religion, and the one shared with philosophy the moment in which art becomes more conceptual and aware of itself. I maintain that this is our current condition, a condition that, in my opinion, even this conversation reflects.

3

THE ANGELIC VS. THE MONSTROUS

(1998)

DEMETRIO PAPARONI: It is often said that cinema is the art of the coming century since it is the sum total of all expressive modes: the image, performance, narrative, fiction, the true to life or surreal reproduction of reality, music. Now with the use of computer graphics this power is even stronger, and it seems that cinema can show things that other arts cannot. And, finally, its ability/need to reach as many people as possible means, in an advanced capitalistic society, not just having a quantitative value but an aesthetic one, too, so much so that one might think that cinema is superior to painting.

ARTHUR C. DANTO: It would scarcely have appeared to those living in 1898 that cinema was to become the defining art of the twentieth century. In fact I am

43

uncertain that it merits that description at all. Painting, the visual arts in general—including those that have used cinematic techniques—have been so much more experimental and transformative than cinema, which has by contrast seemed aesthetically retrograde.

Etymologically, "cinema" derives from the Greek word for movement; its initial ambition was to directly represent motion. Through history, painting has made use of various techniques to depict movement. It has done so indirectly, by making us believe that a certain thing is moving. We perceive that Saint George moves his arm, even if we don't really see the arm move. With moving pictures, we actually see the arm moving, as it plunges the spear into the dragon that, in turn, writhes in agony and breathes flames. Photography was initially on equal footing with painting or drawing, as far as its representational powers are concerned, but cinema went beyond what painting or drawing could do because it represents motion in such a way that we can see movement take place. This was initially the result of optical devices. But nothing could have led to the belief that it was to become the artistic medium of the twentieth century. When the Lumière brothers

invented moving pictures, it was a technological breakthrough but hardly an artistic one, since, for them, it was enough simply to show movement, and to select subjects for their ability to move, the way the inventors of perspective chose subjects that perspectival representation could exploit—like colonnades or coffered ceilings. Initially it was entertainment on the level of the stereopticon. It should have cloyed very quickly, as most technological refinements do.

DP: Yet film never entirely abandoned its optical origins.

ACD: Yes, special effects, which have become such an important aspect of film today, are a testament to this. The true insight was that if we added narrative, we could tell stories in images. But let's remember that the story is a very ancient art form. Film at its best is a story told through pictures, an animated narration, not that different from a play. Of course one can achieve effects unavailable to the static images of painting or photographs, but not unavailable to stories, like the ones told by the great avant-garde novelists—like Joyce, for example. Still, as a

popular art, of course, cinema is rarely able to venture into complex narratives. So the stories told have scarcely evolved at all. It is always the same old story, a tale of love and glory, a case of do or die. And what more could be expected of an art which is the logical product of elementary stories and optical devices?

DP: I don't think this option of yours is valid for "non-popular" cinema. I have in mind above all Eisenstein, Lang, Bergman, Kurosawa, Fellini, Wenders . . .

ACD: Perhaps I was misled by your thought that in our society there is a need to "reach as many people as possible." You have of course cited some of the great cinematic artists of this century. I cannot imagine what their successors in the century to come will do—we really cannot imagine the art of the future, which makes it difficult to know whether cinema will continue to be the art of the future as it was for our time. Moreover, there are reasons to doubt that cinema will be greatly different in the century ahead. In 1880 people believed that opera, as conceived of by Wagner, would be the art of the future. Yet the opera of the twentieth century, with all its merits, certainly has not become the emblematic art of our century. Furthermore, there are reasons to doubt

that cinema will be very different in the future. Most of film's potential was discovered early—the close-up, the two-shot, the fade-out, the flashback, the zoom, the pan. Do you think twenty-first-century filmmakers will extend this repertoire? The use of music, for example, to express the mood with which one is to view a scene, goes back to the nineteenth century, when plays would use orchestras to achieve the same effect. And the piano, playing "movie music," was a complement to silent film. Music creates suspense, expresses tranquility, announces climaxes. This goes with narration, and I would say the use of the music implies a limit on cinema as an art, since we don't have soundtracks for the novels we read, and evidently the writer is able to direct our feelings through words and rhythms. Imagine packaging a CD together with a novel, to be listened to as one reads! I loved the soundtrack by Jonathan Bepler for Matthew Barney's *Cremaster 5*. But that film was about music, and Bepler in fact had to compose romantic music to go with the exceedingly romantic mood of the film. My own view of Barney is that he is a distinguished artist, but that he comes out of the visual arts. If someone were to say that Matthew Barney—he is, after all, quite young—would be the great artist of the next century, I

would be prepared to believe that. But he is not going to reach that many people, or make that much money. In fact, with art like that there is a problem of finding enough money to make the film. And I think, finally, that the extreme cost of making movies leads to artistic conservatism: the producers just can't take chances. So my view is that the cinema of the next century will be more like *Titanic* than *Wild Strawberries*, except for the small experimental films like *Cremaster*. But *Cremaster* itself belongs to our present pluralistic moment, along with installations, performances, mixed media, and painting. It is simply an alternative among alternatives, however marvelously achieved. I guess in the end I have difficulty thinking of *Cremaster* as cinema at all. It is somehow visual art to which the potentiality of film has been added. It is not "entertainment."

DP: I don't think that the directors of the twenty-first century will be very different from those of today because they cannot add new emotions to those we are already used to. Computer graphics can make a situation more credible, but this does not mean making new emotions.

A few days ago I visited the collection of paintings at the Pinacoteca Ambrosiana (Ambrosiana

Art Gallery). There were the big preparatory car-
toons by Raphael for the *School of Athens*. All
together, the cartoons were as big as a movie screen,
and facing them were seats like the ones in cinemas.
The light was dim, to protect the drawings, which
also made me feel like I was in a cinema. So I looked
at these big drawings in the same way that I would
watch a movie. Nevertheless, although while watch-
ing a movie one action follows another, in the *School
of Athens* everything happens simultaneously. So the
spectator can choose his own sequence for looking
at the various parts of the work. For me it was like
looking at a kind of interactive narrative. Probably
cinema has changed the way we look at paintings
of the past; they had a narrative structure that mod-
ernism refused.

ACD: I have seen paintings filmed with a camera that
moved from one part to the next, imitating the
movement of the eye. So we get some angels blow-
ing trumpets, Christ's face in his moment of agony,
the weeping Madonna, and the like. I don't think
this helps us see the painting. If anything, it is a
solution to the question of how to make a film about
an essentially still subject. Even if there is a parallel
between the camera's movement and that of the eye,

it is rarely identical. The camera tries to make narrative connections for us, when in truth the narrative we derive from ordinary pictorial perception is the correct one. What I think cinema has given us is the ability to visualize literature. The tracking shot in the second book of the *Iliad*, the great distance shot as Priam carries the body of Hector back to Troy, the close-up of the Achilles and Agamemnon argument—but Homer was able to do the same things in words.

DP: The cinema has given us many monsters: the latest Godzilla—which is nothing compared to the original—is having great success, even here in Italy. Horror sells because it's cathartic. Just as Greek tragedy had a cathartic effect, so too do these horror films seem to exorcize subjective and collective anxieties. The alternative to the monster is the angel. And more than in saints it seems man finds an antidote to even the most terrible situation in angels. It's no accident that the figure of the angel is common to both literature and popular traditions. Quite recently my daughter asked me if angels really exist.

ACD: Angels do not exist, but we wish they did, provided they were good, and ready to help us in troubled

times. The same figures are found in religious cos-
mologies everywhere, like Kwan Yin in Buddhism,
who shatters the executioner's sword, or rescues a
drowning man. Then there are protective saints who
intervene when we have reached the limits of our
own powers. And if the angels were nice thoughtful
males or females with beautiful wings, our wish
would be to be embraced and protected by them,
nestling against their feathery breast (I wish there
were an angel who could be at my side when my
computer acts up). We love monsters because we
know that we are safe and seated in a theater. It is
like a child being told a ghost story while he sips his
cup of hot chocolate safe in his bed. It is like listen-
ing to the wind howl when we are snug in our beds.
Both monsters and angels return us to our child-
hood selves, and I tend to think cinema rarely goes
beyond that. Unless humanity changes radically, I
cannot see the movies of the next century greatly
differing from the current ones. One can say, I sup-
pose, that, in the infantilization of viewers, movies
do something that painting is not often capable of.

4

ART CRITICISM AS ANALYTIC

PHILOSOPHY

(2012)

DEMETRIO PAPARONI: When did you begin to take an interest in art?

ARTHUR C. DANTO: Between 1942 and 1945 I was a soldier in Morocco and Italy. I found a copy of the *Art News Annual* and was struck by two paintings, Picasso's *La Vie*, and Philip Guston's *Sentimental Moment*, for which he won a prize at the Carnegie Biannual. Both of these paintings gripped me, and I decided that I would become an artist when the war was over. This was not difficult to do, since I was entitled to four years of education under the so-called GI Bill of Rights, a law that provided aid for veterans. I registered at Wayne State University in Detroit as an art student. It was not a strong program, but I used to spend a lot of time in the great

Detroit Institute of Art. I was particular moved by German expressionist art, and especially by the prints, mostly the woodblocks and lithographs. I thought I could make woodblocks easily, mostly the black-and-white woodblock prints.

DP: Have you ever thought of becoming a painter?

ACD: I was never a good painter, either in oil paint or in watercolor, but I was a strong draftsman, and developed my talents to the point that I could find room in any of the Detroit galleries. I had a lot of energy, and worked through the night. But I wasn't happy with what they taught me in school, so I took history classes. I was able to finish my undergraduate education in two years, and I decided to move to New York with my first wife, Shirley Rovetch. And impulsively I applied to the graduate program in philosophy at Columbia and New York University. Columbia accepted me on probation because I had no credits in philosophy; NYU turned me down.

DP: Did you stop painting at that time?

ACD: Not immediately. I showed my work in the print galleries, especially in Associated American Artists,

the Robert Elkon Gallery, and the Contemporary Gallery in New York. I had no hope of being a professor, but as my work sold reasonably well, I knew I would be OK when the aid from the GI Bill ran out. It took me awhile to get hold of philosophy, but it turned out that I had philosophical talent. I wrote a paper on Kant for the philosopher Susanne Langer, which she praised. I won a Fulbright Fellowship to the Sorbonne, and developed the beginning of a philosophy of history. I was given a position at the University of Colorado, where I discovered analytic philosophy. At Columbia they didn't know what analytic philosophy was, but it was pretty new and exciting.

DP: When did you go back to New York?

ACD: I left Colorado in 1951, and returned to New York. Luckily—I am a very lucky person—I got a position at Columbia and stayed there for my entire career. I had no special interest in aesthetics, but conceived of a plan of writing a five-volume work on analytic philosophy. In 1962 I gained tenure, and wrote my first volume, called *Analytical Philosophy of History*. Then I wrote a book on the theory of knowledge and one on the theory of action. In 1964

I had a major insight when I saw my first Warhol show. Andy's work turned me into a philosopher of art. In that year, I wrote my first essay on art called "The Art World." In 1978, my wife died, and I finished my book on art called *The Transfiguration of the Commonplace*. That, I think, is my most important book.[1] It was widely discussed, and out of the blue I was invited to be an art critic at the *Nation*. It was America's oldest journal of opinion. Founded in 1865, it included art criticism from the beginning. Clement Greenberg was a critic for it from 1942 to 1947. Then there was Lawrence Alloway, who got sick. I was called and offered the job, though I had never written criticism. The founders of the magazine were disciples of John Ruskin. His view was that if the art and architecture were OK, the society would be OK.

DP: When I met you for the first time, in the second half of the eighties, in New York people referred to you as to the "new Clement Greenberg." On one hand it was strange because you never shared Greenberg's views, but on the other hand you had taken his place at the *Nation* and you loved abstract art. The American art world was looking for a leader and everyone thought that you were the suitable person

for the role. At that time you had a predilection for the abstract painters Sean Scully and David Reed. I was very surprised when Donald Kuspit wrote that Sean Scully's paintings are more powerful than Mark Rothko's. Thanks to that statement I realized that it's possible to say that a contemporary artist is more interesting than a master of the past. I considered Scully more powerful than Rothko, too, but at that time I wasn't brave enough to say it. Recently, standing before the works of the abstract Chinese painter Ding Yi, I felt the same emotions that I felt in front of Scully's paintings.

ACD: I have always loved Sean Scully's work, probably because I really loved Sean himself. We met in 1983, and we've been friends ever since. It was the same between Motherwell and me, in 1985. You and I are fortunate to have artists as friends. Sean isn't an academic or an intellectual. He is above all of that. Sean is a mind, that's what he is. He loves my writing, as I love his paintings. I have a small painting of his from 1983, the year he invented the stripes, which he has used ever since.

DP: Let's go back to Greenberg. There are many differences between you and him. Still today, whether one

likes it or not, we reckon with his thought. In his essays from the fifties, Greenberg gave strong limitations to the work of the American artists, he laid out a border that an artist couldn't cross if he wanted to be considered modern. This way he could state the superiority of American art over European art. In defining the modern and innovative character of abstract expressionism, Greenberg gave priority to the artist's subjectivity and to the absence of narrative, and the absence of literary and symbolic dimensions in painting. Greenberg had already outlined this idea of art in his youthful essay "Toward a Newer Laocoon," published in 1940. In this essay Greenberg considered narrative and symbolism to be more tied to literature than to the visual arts. So he considered the narrative dimension a boundary that visual artists could not cross if they wanted to operate within the tenets of modernity. He resumed and developed these principles in about 1947 as a backing for abstract expressionism and, later on in the first half of the 1960s, in support of post-painterly abstraction (Sam Francis, Ellsworth Kelly, Morris Louis, Kenneth Noland, Jules Olitski, Frank Stella). Greenberg had an evolutionary idea of art and he did not recognize any kind of break with the past in the characteristics of the various forms of abstraction he

supported. This allowed him to theorize that ratio-
nal and objective post-painterly abstraction was an
organic development of abstract expressionism
that, instead, was emotional and subjective. The
contrast between figurative and abstract art posed
by Greenberg—known as the "formal problem"—
became a real discriminating factor for him with
regard to figuration and found support in the atmo-
sphere of opposing ideologies that had developed
with the Second Industrial Revolution. Modernist
criticism was part of this climate and was also for a
long time influenced by communist ideas derived
from Marx and Engels, who had realized that the
conflict between capital and work would lead to
other irreconcilable conflicts, hence the tragic
dimension of twentieth-century art. What is left of
Greenberg's vision in the current art of the West?
Did we really get rid of it? Or do his ideas still influ-
ence both the artists' work and the critics' thought?

ACD: Greenberg's view of contemporary work was
that it was Kantian—an effort to find the essential
properties of the various genres. In his opinion,
painting was essentially flat, and sculpture was essen-
tially three-dimensional. I don't share your thoughts
about him. His article "Modernist Painting" was

published in 1962, when abstract expressionism was finished. The movements of the sixties— Fluxus, pop, minimalism, and conceptual art— came along. Greenberg carefully read my reviews in the *Nation*. I know that because he went to the shows I reviewed. He read my reviews, and invited me for drinks one day.

DP: What did you say to each other?

ACD: He told me that he had been asked to write something for a blurb for a book I was publishing but he refused. I asked why, and he said he did not agree with me. I said that would not have stopped me. I spent a lot of time with his "Modernist Painting" essay, which was very interesting. Greenberg did not study philosophy—he was a New York intellectual, formed by *Partisan Review*. He wrote for the *Nation* from 1942 to 1947, then resigned. He was of the generation before mine. I respected his achievements of discovering Pollock, and trying to establish a theory that would hold water. Remember, after having been a soldier, I was an academic most of my adult life. Greenberg was not an academic, but an intellectual. He could never have published in an academic journal. I think intellectuals

are socially valuable, especially when relatively few go to universities.

DP: I also think that the generation gap played a role in making you two so different.

ACD: Of course, there was also a certain generational difference.

DP: Did *Partisan Review* influence you both?

ACD: When the war ended, I read *Partisan Review*, but I was interested in Sartre, and ultimately wrote a book on him. Existentialism entered America through *Partisan Review*. Greenberg and I were in two different worlds.

DP: I am interested in highlighting the differences between you, the disagreements.

ACD: I don't agree or disagree with Greenberg's journalism. I read the *New Yorker* every week, but I seldom agree or disagree. It is just reading material. The New York Jewish intellectual is a thing of the past, to disagree with that is precisely to be a New York Jewish intellectual.

DP: Sorry, but I'm going to be insistent when it comes to Greenberg. Do you agree with his distinction between abstract and figurative art? Do you share his belief on the superiority of American art over European art? Do you think that, when it is narrative, art stops being modern, as Greenberg said? Do you think that modern art was born with Manet, as Greenberg said? Do you think that post-painterly abstraction is an organic development of abstract expressionism, as Greenberg theorized?

ACD: I would agree with that. The rest is journalism. Obviously, Greenberg would consider narrative essential for literature. So, as he sees it, narrative painting is not modern. He was a major figure, but formalism cannot define art. You need meaning, which is my contribution, and embodiment. My new book will discuss that.

DP: What is the line that distinguishes art criticism from a philosophy that deals with art?

ACD: When I became an art critic, I usually tried to find out what the art I was writing about meant and then how one discovered the meaning. It was not like reading a sentence I was interested in, but

interpreting a literary text, finding what I called "embodiment." Actually, this was close to Hegel's idea of criticism.

DP: Can you explain what you mean by "embodiment"?

ACD: To be considered a work of art, an object must have content and must embody meaning.

DP: Do you still think that it was necessary to stop painting? Being an artist and writing about art are not mutually exclusive.

ACD: In 1962 I was still making block prints. I thought: "Why am I doing this? Why, now that I am writing what I love, namely philosophy?" I decided to dismantle my studio, and I never drew again, let alone painted. In a way that was my entrance into philosophy. I published the book on history, and a book on Nietzsche, treating him as an analytic philosopher.

DP: Which analytic philosopher influenced you most? Bertrand Russell, Ludwig Wittgenstein, or someone else? Was there a particular thought of these authors that caught your interest?

ACD: I never became anyone's disciple—Russell, Frege, Wittgenstein, Austin—everyone knew about their basic ideas. But analytic philosophy was a movement. I learned a lot from Elizabeth Anscombe's book *Intention*. Everyone learned from John Rawls's book on Justice. Philosophers read the philosophy magazine *Mind* from cover to cover, the way American artists read *Cahier d'Art*.

DP: From Action painting we inherited the freedom to accept mistakes, the runaway spatter of color. From the pop art of the sixties we inherited the language and the iconography of commercial propaganda and the star system. Since the end of the seventies, with the birth of postmodernism, art has often drawn from and mixed all the languages. Obviously, the more languages are present inside the same work, the lesser the influence of any singular language. I wonder if works of action painting and pop art still have something to teach us or if they should be considered "archeology."

ACD: In America, in those years, there were two social phenomena, the end of the Vietnam War, and the surge of women into art schools, which raised certain questions. The machismo of the abstract

expressionism treated painting as a male thing, leaving it politically necessary for women to find new ways of making art, and this led to two features of the seventies: sculpture and photography. In those years, sculpture widened, beginning with Eva Hesse, Mary Miss, Audrey Flack, and several men—Charles Simonds, Gordon Matta Clark, Robert Smithson, Sol Lewitt—they produced sculpture of a kind that had never existed in fine art, using materials like cinder blocks, stones, pieces of houses and food (Matta Clark), and so on. I also remember a sculpture shaped like a dress made by a female artist whose name I can't remember. No man would ever make art like that. There was painting, but no painting movement. Thus Robert Mangold, Sean Scully, and David Reed were wonderful painters, but were not part of any movement, though monochrome painting, led by Marcia Hafif, was a kind of movement. At the end of the decade, photography went with performance, in the work of Cindy Sherman and Francesca Woodman, and in the work of Shirin Neshat, who was inspired by the Iranian Revolution in the nineties. The art world became globalized in the eighties, and though there was a kind of movement at the cusp of the eighties in pattern and decoration, it

was more or less seen as an alternative to minimalism. After this, collectors and dealer began to look for talented individual artists. I guess pop and action painting really became "archeology," to use your word, though artists may have dripped paint, consigned work to production, etcetera, but in general everything was acceptable.

DP: It had become acceptable also to faithfully reproduce packages of consumer goods, as Warhol did with the Brillo Box, faithful reproductions of boxes of abrasive sponges used to clean aluminum pots, a product that has been very common in American supermarkets since 1963. In 1964 Warhol made his copies by screen-printing on plywood.

ACD: Yes, but their importance was not immediately understood. Warhol's boxes sold for about $300 in his first Silver Factory project, purveyed by the Stable Gallery in 1964. The Brillo Box from 1964 had an auction bid of $2 million when Pontus Hultén had ninety boxes forged by woodworkers in Lund, in Sweden, which he "authenticated" as made in 1964. The notion of "specific objects," which was tied to Warhol's Brillo Box, introduced a fresh way of thinking about minimalism, which used florescent

lamps (Dan Flavin, Keith Sonnier), metal tiles and bricks (Carl Andre, Sol Lewitt, Richard Serra, Tony Smith), felt (Robert Morris), and Judd's metal sets of units, which he sent out for production at the machine shops. Warhol's boxes were produced in woodworking shops. Then conceptual art rang in the seventies.

DP: We are inclined to think that conceptualism and minimalism, that developed in the early sixties, a few years after the birth of pop art, are analytical languages par excellence. Do you think that the current Western culture is still influenced by the sixties? Or have we moved so far past it that art of that time should be considered "ancient" like the works of the Impressionists and Cubists?

ACD: I think that art historians, as well as art critics, must begin to explore the seventies in a deeper way. Abstract expressionism, as a movement, was pretty much finished by 1962, and replaced by the great movements of the 1960s: Fluxus, minimalism, pop, and conceptual art. Fluxus brought music into the mix, minimalism changed sculpture's vocabulary, pop opened the door to commercial icons (the Brillo Box, Campbell's Soup, and the comic pages of the

newspaper), and conceptual art opened art to almost anything, like Robert Barry opening a tank of gas that diffused itself in the atmosphere. All of these led to questions about the commercialization of art.

DP: The works by Robert Barry you talk about date back to 1969. In Robert Barry's view, dispersing gasses like helium in open spaces meant creating three-dimensional artworks, sculptures. His idea was that, even if we cannot see it, gas takes a shape in the air. At the same time, due to its volatile nature, the sculpture expands infinitely in space. Obviously there are no photos of these works and it was not possible to sell them. It was the European galleries that provided economic support for American conceptual art. Gallerists like Gian Enzo Sperone and Massimo Minini showed and sold works by Robert Barry in Europe. Do you think the success of these artists was determined by critics or by the market?

ACD: Robert Barry was a conceptual artist. It was more difficult to sell that kind of work than to make it. That was generally true. Seth Suegkaub was a conceptual art dealer, and did pretty well. But conceptual art didn't need galleries.

DP: Let's go back to talking about the sixties. In your essays you highlighted the analytic-conceptual roots of pop art. What is the relation links philosophy and an art that draws on the aesthetic canons of advertising posters and mass communication? Before becoming artists, pop artists worked in advertising: Andy Warhol was an illustrator, James Rosenquist was a poster designer, Wayne Thiebaud collaborated with Disney, Tom Wesselmann made cartoons, and Ed Ruscha was a typographer.

ACD: Well, the main pop artists—Roy Lichtenstein, Claes Oldenberg, Jim Dine—were artists before they were pop artists. I heard Roy say that he wanted to erase the division between high art and vernacular art. His great painting from 1962, *The Kiss*, left Leo Castelli wondering whether he should hang it on the wall or not. In a way that painting was like the portrait of Èmile Zola with Japanese printings in the background, made by Manet in 1867. I remember thinking, when I first saw *The Kiss*, that if it was art then anything can be art.

DP: Pop art paintings depicted bottles of Coca-Cola and logos of big American multinational companies

but also faces of movie stars and everyday objects glued on the surface of canvases. After more than half a century, these works seem to be talking about the physical decay of the individual and of the biological death to which each object is destined. I see pop art as a form of dramatic realism that also claims social equality, in that it carries with it the illusion that we can all use the same washing machine or car.

ACD: Your view is very European, almost Marxist. Most European critics treated pop as a critique of capitalism, so it is Marxist to that extent, whatever their politics might be. Marx and Engels were very smart guys, making metaphysics out of economics. I don't have any problems with that. I used to teach Marxism at Columbia. It is true that pop art is part of American culture: everyone knows, without asking, what Campbell Soup is, who Elizabeth Taylor is, etcetera. Warhol and Lichtenstein loved the subject matter of pop and always loved the modern world where people had refrigerators and storm windows. He [Warhol] loved stars. Pop was very popular. When you see works by pop artists you know what they are about and you don't need to ask experts. Pop art, wherever it appeared, was popular:

in Germany, in Eastern Europe, as much as in America and England.

DP: Yes, pop was very popular.

ACD: You don't have to ask the experts in order to understand these works. That is Jeff Koons's attitude. Trust your own judgment. If you like the pig being pushed by angels, like little statues that can be bought in airports, don't let Rosalind Krause tell you otherwise.[2] In that sense, the paintings by Roy that turned de Kooning's brushstrokes into prints were political cartoons.

DP: I understand what you mean: making an art that is both avant-garde and popular has political implications. You think that Warhol's Brillo Boxes radically changed the perception of art. You said that when he showed them in a gallery for the first time it was unthinkable to accept something like that as art.

ACD: The exhibition was held at the Stable Gallery on 74th Street in April 1964. I thought it was art right away. So did Leo Castelli: he considered it sculpture. But Eleanor Ward, the gallerist, thought she was being mocked by those works. In 1964,

I published "The Art World," and it changed the whole direction of aesthetics. My question was about how an object is franchised as art. 1964 was the year of the Summer of Freedom, the campaign that tried to increase African Americans' right to vote in the south of the United States and to favor a real equality between Black and white people. Many northern whites joined Black activists to help Blacks claim their right as citizens. They had the rights already; it just was a question of claiming them. That left the question of what freedom is open, just as pop art left open the question of what art is. It was as old as book 10 of Plato's *Republic*. But Socrates's solution—art is imitation—did not survive abstraction.

DP: Imitation is probably the expressive form that most mirrors visual experience. Contemporary art, however, has moved away from imitation, considering it an academic remnant of the past. How do you see the relationship between visual experience and aesthetic experience when standing before a work of art?

ACD: Think of pigeons. I have often used this example. Their vision can be considered the lowest level of

visual experience. If a pigeon sees a tree, it grasps the eidolon in the tree, the simulacrum of the tree itself. For us, on the other hand, this is linked to a dense network of associations that we have stratified over the course of our lives, through experiences beyond just the visual. If we lose this network of connections our lives would be reduced to a primitive pigeoning. I'm not, however, completely convinced that the visual experience of pigeons is degree zero of perception, because they are capable of accumulating memories tied to stimuli. When we approach a work of art our visual experience is anything but minimal, since references to things we have seen, read, and thought through our lives are created. The work we stand before interacts with all these things.

DP: In other words, the gaze never expresses purity, because what we see is the product of the relations that our mind establishes between the object we face and the things we already know. Does this mean that people who come from different experiences see different things when positioned before the same object?

ACD: A visual text is tied to the experiences we have had through the years. It varies according to the

author's points of observation. This point of view can never be original, primordial, or primitive. A crooked tree can bring to mind Chuang Tzu's image or Johan Christian Dahl's oak tree. These two trees have nothing in common except the base visual experience. I think that this experience should be positioned outside the visual text. But this task is nearly impossible because we can never separate ourselves from the layers that our experience has created in our mind over time.

DP: This means that even the historic context is inscribed within the dynamics of memory, beyond the personal experiences and cultural formation of the individual.

ACD: The artist and the work are positioned in a set historic moment, but at the same time the work transcends its time precisely when it expresses a universal message. This universality has long been determined by criteria shaped by Western tastes. I believe the moment has come to understand universality in the integration of different cultures. Works of Chinese art exist that transcend the geographic and cultural borders in which they were made and that speak in universal terms.

DP: This means that if we were once accustomed to associating universality with the classics of the Greco-Latin tradition, today we must be ready to consider texts from the Chinese tradition classics as well.

ACD: The universal values are considered as such because they do not necessarily identify with the place in which they were created. Johan Christian Dahl's oak does not express a Norwegian value, just as Chuang Tzu's braided tree does not just express Chinese values. They allow us to share the same humanity.

DP: And the critic's role in all of this is . . .

ACD: It consists in distinguishing a profoundness from a superficiality. Superficial interpretations point to what the public understands in the work, attributing it to the artist's intention. Intentions attributed to the artist however can limit interpretation. Deep interpretations are instead those that set aside the artist's intentions. Recently I have spent a lot of time on this theme, using Piero's *Resurrection* as an example. We know that this work expresses the Renaissance world, but we cannot be sure if this was what Piero had in mind.

DP: The artist's work can become more or less important than it is when it is created. Your thought gives Warhol's work a central role. Do you think his art is destined to be considered even more important than it already is on an historic level?

ACD: Look at the auction prices for pop! Andy's self-portraits are more and more expensive. Ditto for Roy's paintings. Andy was like King Midas—everything he touched turned to gold. Perhaps he got that from Duchamp, who, in 1915, told reporters that European art was washed up and in particular that painting was washed up. He made beauty obsolete in art with the readymade. Anybody can buy a snow shovel in a Columbus avenue hardware store. Andy's were also common objects. One of Andy's "experts" told him to paint something that everyone could recognize, like a can of soup or a dollar bill.

DP: There is a big difference between Duchamp and Warhol: Duchamp took an existing object and exhibited it while Warhol reconstructed it, represented it. Before Duchamp nobody had taken an object like a snow shovel or a bottle rack and showed

it as a work of art. But even if Duchamp stated that he chose those objects for their ability to leave us aesthetically indifferent in the face of them, he had to build a strong theoretical structure in order to legitimize those objects as artworks. I mean that, if you don't know Duchamp's motivations these objects remain mere objects even if you show them at MoMA: they become art just for those who know their "dynamics," their meaning. In the case of Andy Warhol, Roy Lichtenstein, and pop artists, it is a question of style. Today we know that a style and perceptive strategies exist that connote pop art. Pop art didn't want to leave people cold but to involve them through visual emotion. Moreover, pop art built the scene of the painting with a structure that, often, is not very different from the structures that characterized paintings of the past. Given the nature of pop art, don't you think that today even works that are far from that experience are read as pop?

ACD: In 1969 Duchamp said that the readymade was art without being beautiful. He only did about twenty readymades. And he was quite down on what he called "retinal art." And loved using the silkscreen since he felt no one could tell who made

the drawings, him or his assistant Malanga, or any-
one else. And Warhol really loved American things;
a "wonderful world" he used to believe in.

DP: Do you think that representing Mao on the same
level as Marilyn Monroe or Elvis Presley was dis-
respectful to Chinese culture?

ACD: I don't know, but I know Andy did not do it out
of disrespect. He did see Mao as a star, of course.
But he made Mao the way he made Brillo Boxes. Is
that disrespectful? He thought his big Chairman
Mao was brilliant, but he was not thinking of its
impact on the Chinese at the time. Andy was never
disrespectful that I know of.

DP: Warhol made those portraits of Mao at a time when
many young Westerners carried the little red book
in their pockets. Antonio Homen, who worked with
him for a long time because he was the director of
Sonnabend Gallery, once told me that he asked
Andy why he had done those portraits of Mao, and
Warhol answered that Mao was very fashionable at
the time. Funnily, in those years, in China, a deifi-
cation process of Mao was taking place. Socialist
propaganda wanted to show Mao as a God. The

same years he painted the portraits of Mao, Warhol wrote that people need stars more than anything else. In the past few decades, many Chinese artists are humanizing the figure of Mao in contrast with the way Mao was seen before. There is a very interesting cycle of works by Wang Guangyi that deals with this theme. Do you think that Warhol had political intentions when he made the portraits of Mao?

ACD: Warhol was political, in the sense that he was a Democrat. Fred Hughes, Warhol's business manager, did the negotiating for him to make the portraits and sell them. He was a Republican. I dedicated my book on Warhol to Barack Obama because I wanted Obama to know that Andy was a democrat.

DP: Do you know how Warhol's work is perceived in China?

ACD: I just read that a wealthy Chinese collector recently bought the last of the four giant Maos.

DP: Warhol said that, unlike wine, Coca-Cola is the most democratic drink, because the Coke that a bum drinks is the same as the one that the the stars

of Hollywood or the president of the United States drink. Do you think that this statement makes Warhol a Marxist?

ACD: It makes him a Maoist.

DP: Since the end of the seventies, artists haven't been able to invent new languages. I wonder if, after the birth of postmodernism, Western culture has given up a linear and progressive vision of art, or if nothing has changed since the 1900s.

ACD: What changed in the seventies was that painting stopped being the canonical medium. That was due to feminist disgust with the machismo of abstract expressionism. They used to say, as a compliment, that a good painting by a woman "looked like it was done by a man." Feminist critics began to seek a medium that was ideal for the many women that were entering the art world. Sculpture was OK, and photography. In the beginning of the seventies there was sculpture, at the end of the seventies you had Cindy Sherman and Francesca Woodman. The seventies was the last American decade. After that came globalism, and the whole concept of the art world had to be revised.

DP: We keep considering art as a sort of evolutionary chain. For example, we know that Dadaism generated surrealism and that the automatism of surrealism generated the action painting of which we find traces in certain paintings from the eighties. Or we find some aspects of Dadaism in the behavioral art and the body art of the seventies, so we know that Duchamp generated Gilbert and George who in turn generated Cindy Sherman, etcetera. This progressive view of culture led many Western people to think that contemporary Chinese art derives from Western art. In your 1997 book *Seeing and Showing*, you published an essay on the historical development of the image where you asserted that the way things are represented doesn't depend on the way they are perceived. So the different ways to represent reality depend on the ability of the artist and on cultural and political factors that lie outside the way reality is perceived. Your reflection concerned the absence of perspective representation in the Chinese art of the past.

ACD: The Chinese knew about exact resemblances, especially in the nineteenth century, when photographs entered their culture. But they disdained them as having nothing to do with what they felt portraits should be.

DP: Once, in the apartment of the artists Lin Tian-miao and Wang Gongxin, in Beijing, I saw a small painting dating back from the eighteenth century that follows Western perspective. Wang Gongxin explained to me that the painting is by an unknown artist who lived in China around the same period Giuseppe Castiglione did. Tianmiao and Gongxin bought this painting from an auction company in London. Probably it will be the task of Chinese artists and intellectuals—more so than politics and the private economy—to reconstruct the link to the past. In the near future China will need to recover as many ancient artworks and artifacts of the past as possible, especially from abroad, and establish big museums.

Understanding the scene of contemporary Chinese art is very complicated for a Western person. If we study it we realize that certain similarities with our art exist only in appearance. It's like if at the end of the eighties Chinese art had made something similar to what Manet did in 1863 and Duchamp did in 1913 in the West. Chinese art traced a borderline between old and new ways. Obviously, Chinese artists that have lived in New York or Paris for a period have been influenced by Western art, but by and large the Chinese avant-garde of the

nineties took its own path. During an interview, Yue Minjun told me that looking at art from a Western or Eastern perspective could be a limitation. The best position is to stay in the middle and take something from the East with the left hand and something from the West with the right. Not insisting too much on the differences between East and West would help us fix many contradictions and eliminate a lot of problems. If this were really to happen—Yue Minjun said—we'd find ourselves all facing the same problems together. In another interview I recently gave, Wang Qingsong said something similar. In his opinion, regarding economics and the market, China today is more Western than the West. Culturally, and also politically if we want, China has maintained its own identity and indeed has no intention of becoming Westernized or conditioned by the West. So he concludes that by combining different elements of Western and Chinese culture we can create something prestigious and new. Wang Qingsong's installation *Happy New Year* at Tang Contemporary Art in Beijing included objects hanging by a thread from the ceiling, a head of lettuce, a chair, and so on. An installation like this leads Western people to think of the hanged object by Duchamp or Giovanni

Anselmo's works with lettuce from the late sixties. The tradition Wang Qingsong draws from, instead, is not ours. For this reason we can't think that there is a primacy of contemporary Western art over Chinese art. What I mean is that the fact that Giovanni Anselmo showed a head of lettuce in 1968 doesn't make him a reference for Wang Qingsong. Do you think that the language of our art, due to the spreading of images in the age of the Internet and global communication, has contaminated Chinese art independent of the Chinese artists' will? Do you think Asian art can remain autonomous from Western art today even as it uses the languages of modernism?

ACD: A lot of Chinese art was an appropriation of pop. Turning figures of the Red Guard into pop, as Wang Guangyi did, is a good example of what I was talking about—pop has been liberating. I only marginally know the Chinese artists you were speaking of. I saw a number of Chinese artists' work at Pace, at Protetch, and at Asia House here in New York. But I am in no position to judge fineness because I am not an expert of Chinese art. The best work I have seen has been a performance. My reputation in China is based on my theories of art, as it is elsewhere, not on

my knowledge of Chinese art. For example, the artist Pan Gongkai came to spend several hours with me a few weeks ago. I know his work, but that is not why he came to question me. I admire Pan Gongkai's lotus paintings, which are connected to the great ink painting tradition in China. We were lucky not to have had a Mao in our history. Politics in the twentieth century changed everything. Think of the totalitarian art of Germany, Russia, and Italy. Art has not been autonomous in most parts of the world. For the most part, France has been pretty benign—but even there the *rappel à l'ordre* forced many artists to return to what was considered traditional.

DP: American art has experienced seventy glorious years of experimentation. Contemporary Chinese art is only twenty-five years old. Does this make contemporary American art superior to its Chinese counterpart?

ACD: It would be ridiculous to think American art is superior because it is three times the age of Chinese art. I don't see much that I consider good in Chinese art, however. In general, there has been a great falling off everywhere, which may be just the art of our times.

DP: Western artists usually have a unique, recognizable style. Chinese artists instead often create works with different styles at the same time. On a conceptual level, they follow an idea, but they are linguistically eclectic. When I asked Yue Minjun why he uses different styles and subjects, he answered that he does so because he wants his work to express contradictions. In his opinion China wants to get rid of the logical model, which is common to both the China of the past and to the West. According to this logic, once a style or mode of self-expression has been found, the artist has to repeat the same patterns for his entire life. Do you think that this attitude could become a new element of art on a global scale?

ACD: I have no clear idea about it. An artist like Gerhard Richter has used different styles—his rather extraordinary abstractions and his engaging figurative work. Once an artist adopts such sharp differences, it is hard to know what he believes in.

DP: When Western people use the definition of pop art, they think of the way artists such as Warhol, Lichtenstein, or Oldenburg used images to express their reflections about a capitalist society that is based on consumption and the cult of personality. But

Chinese pop art doesn't reproduce brands of cigarettes like Red Double Happiness or Cheung Hwa that could be equivalent to Coca-Cola or to Brillo. Neither does Chinese political pop art reproduce Deng Lijun's face, a very famous Chinese singer who died because of a depressive crisis and in some ways could be seen as the Chinese equivalent of Marilyn Monroe. I don't think that in Chinese art there has been anything like Brillo Box. A great impulse for change in China did however happen in the early nineties, beginning with Wang Guangyi's *Great Criticism* cycle, which we may be inclined to view as a derivative of American pop, though it isn't. These works mix images of Maoist propaganda and the most common commercial Western brands in order to represent two different kinds of brainwashing: the brainwashing of political propaganda in a socialist country and the brainwashing of Western fetishism. Wang Guangyi takes a neutral position as an artist: he doesn't criticize or oppose something he just shows a situation. He didn't use Chinese logos because he identified fetishism with the products of Western society. This means that Wang Guangyi considered Western logos completely alien to Chinese culture. In 2007 he stopped making these works,

and perhaps this shows that something has changed in the mentality of Chinese people during the last twenty years. Today Wang Guangyi is more interested in spirituality, religion, and philosophy. Do you think there is a connection between the paintings of the *Great Criticism* cycle and the works made by American pop artists in the sixties? Do you think that Chinese art is indebted to American pop?

ACD: No, I don't think that. But think of the impact of Japanese prints on the Impressionists. Van Gogh thought he wanted to be the Hokusai of France. That accounts for his colors and shapes. The Impressionists painted pictures of Japanese prints on the artist's screens. Just think of Manet's portrait of Emile Zola. The pictures of prints were a bit like Roy Lichtenstein's parody of brush strokes.

DP: According to Arthur Danto's philosophy, what is nothingness? In contemporary Chinese art, several artists deal with the concept of nothingness in different ways. A cycle of works by Yue Minjun faithfully reproduces paintings of the past while deleting the human presence from them. Wang Guangyi defined nothingness as "absence from oneself," in the Kantian sense. Zhang Wang's installation *My*

Personal Universe, shown at the UCCA foundation in Beijing, reproduced the Big Bang. Zhang hung flakes of stone to the ceilings with transparent threads. These suspended flakes reproduce the "frozen" explosion of a big rock. Videos projected on the walls and ceilings and the recorded sounds gives the viewer the impression of being in a giant empty space, which, in some way makes him feel surrounded by an enormous nothingness. At the same time in China nothingness indicates full potential; it is the zero that one is born from. What is nothingness for you?

ACD: I knew a Chinese calligrapher, and a Japanese one as well. They loved drawing the character MU, which make the sound "MU." I think they thought they were drawing MU when they were drawing "MU." My sense is that I have no interest in nothingness. If it is nothingness, it is something. When there is nothingness, that is what there is. Wittgenstein wrote that death is not an event in life. But I have never given it much thought. It is interesting that no painter I know of is really interested in nothingness.

NOTES

FOREWORD: TOWARD THE INVISIBLE FUTURE

1. See p. 72, this volume.
2. Arthur C. Danto, "Works of Art and Mere Real Things," in *The Transfiguration of the Commonplace: A Philosophy of Art* (Cambridge: Harvard University Press, 1981), pp. 1–32.
3. Arthur Danto, "The Art World," *Journal of Philosophy* 61, no. 19 (October 1964): 581.
4. Saul A. Kripke, *Naming and Necessity* (Cambridge: Harvard University Press, 1980), p. 91.
5. Thierry de Duve, *Kant After Duchamp* (Cambridge: MIT Press, 1993), p. 32.
6. Arthur C. Danto, "The End of Art: A Philosophical Defense," *History and Theory* 37, no. 4 (December 1998): 131.
7. Arthur C. Danto, "The End of Art," in *The Philosophical Disenfranchisement of Art* (New York: Columbia University Press, 1986), pp. 81–115.

8. See p. 14, this volume.
9. David Reed, "Passages: Arthur Danto (1924–2013), artforum
 .com (March 4, 2014), https://www.artforum.com/passages
 /david-reed-on-arthur-danto-1924–2013–45530.
10. See pp. 16–17, this volume.
11. See p. 26, this volume.
12. See p. 75, this volume.
13. See p. 33, this volume.
14. See p. 54, this volume.
15. See pp. 55–56, this volume.

PREFACE

1. David Reed, "Arthur Danto (1924–2013)," ArtForum,
 March 4, 2014, https://www.artforum.com/passages/david
 -reed-on-arthur-danto-1924-2013-45530.
2. Interview with Arthur Danto, *ArtChina*, June 2012, 32–45. An
 excerpt was published in English and in Spanish in *Arte Al
 Limite*, July–August 2012, 94–102.

IN JUDY'S ROOM

1. Danto's initial responses to the questions that arose after see-
 ing Warhol's exhibition at the Stable Gallery are delineated in
 his essay "The Art World," *Journal of Philosophy* 61, no. 19 (1964).
2. Arthur C. Danto, *The Abuse of Beauty, Aesthetics, and the Con-
 cept of Art* (Chicago: Open Court, 2003), 95.

3. Marcel Duchamp interviewed by George Heard Hamilton, 1959, in *Duchamp: Passim: A Marcel Duchamp Anthology* (New York: Gordon & Breach Arts International, 1994), 76.

4. Marcel Duchamp, "Will Go Underground" (1965), interview by Jean Neyens, trans. Sarah Skinner Kilborne, in *Tout-fait: The Marcel Duchamp Studies Online Journal* 2, no. 4 (2002): https://www.toutfait.com/issues/volume2/issue_4/interviews/md_jean/md_jean.html (accessed October 26, 2021).

5. This is a common view in pop art, so much so that in October 1964 an exhibition entitled *The American Supermarket* was held at New York's Paul Bianchini Gallery, where everything alluded to the presentation of food, consumer goods, and advertisements that would be found in an actual supermarket. The exhibition included works by Billy Apple, Mary Inman, Roy Lichtenstein, Claes Oldenburg, Robert Watts, Andy Warhol, and Tom Wesselmann, many of which were displayed in classic grocery store arrangements.

6. The preliminary stages of this sort of analytical process, identified as the only viable way, are addressed by Danto in his essay "The Transfiguration of the Commonplace," *Journal of Aesthetics and Art Criticism* 33, no. 2 (Winter 1974): 139–48. See also Arthur C. Danto, *The Philosophical Disenfranchisement of Art* (New York: Columbia University Press, 1986), 202–3.

7. *Hiroshi Sugimoto*, Hirshhorn Museum, Washington, DC, and Mori Art Museum, Tokyo, in association with Hatje Cantz, Ostfildern-Ruit, 2005, 221.

8. John Sallis, "Monet's Haystacks: Shades of Time," trans. Natalia Iacobelli, *Tema Celeste*, March–April 1991, 56–67.

9. When he presented *Judy's Bedroom* in his subsequent exhibitions, Reed always substituted the existing painting, both in the DVD and in the installation, with a new one. In Hitchcock's film there are two bedrooms: Judy's and Scottie's. An installation, with a DVD in which the substitutions of the painting take place in Scottie's room, *Scottie's Bedroom* (1994) was presented for the first time in 1995 at the Max Protetch Gallery in New York. At the Kunstverein in Hannover, Reed installed both bedroom sets, *Judy's Bedroom* and *Scottie's Bedroom*, naming the ensemble *Two Bedrooms in San Francisco*.

10. Arthur C. Danto, *After the End of Art: Contemporary Art and the Pale of History* (Princeton, NJ: Princeton University Press, 1997), xiv.

11. Danto, *After the End of Art*, 4.

12. Arthur C. Danto, *What Art Is* (New Haven, CT: Yale University Press, 2014), 151.

13. Danto, *Abuse of Beauty*, 56.

14. See Arthur C. Danto, "Reply to Sean Scully," in *The Philosophy of Arthur C. Danto*, (Chicago: Open Court, 2013), 124.

15. Sean Scully, "Conversation with Demetrio Paparoni," trans. Natalia Iacobelli, in *Tema Celeste*, January–March 1992, 82–83. Also in Demetrio Paparoni, *Il corpo parlante dell'arte* (Rome: Castelvecchi, 1997), 87–90.

16. David Reed, letter to the author, September 18, 1992.

17. Sean Scully, conversation with the author, 1992; see note 15.

18. Scully, conversation with the author.

19. Arthur C. Danto, "The Cosmopolitan Alphabet of Art," in Giovanna Borradori, *The American Philosopher*, trans. Rosanna Crocitto (Chicago: University of Chicago Press, 1994), 101.

20. Arthur C. Danto, *The Transfiguration of the Commonplace: A Philosophy of Art* (Cambridge, MA: Harvard University Press, 1981), 115–36.

21. Danto, *Transfiguration of the Commonplace*, 119.

1. HISTORY AND POSTHISTORY

This conversation took place in Milan on February 11, 1995, in the study of Mimmo Paladino, who participated in it. It was published in the summer of that same year in the contemporary art magazine *Tema Celeste* along with images expressly created by the artist.

2. STYLE, NARRATION, AND POSTHISTORY

The philosopher Mario Perniola took part this conversation, which took place via email between February and March 1998. It was published in Arthur C. Danto, *Narrazione e Stile* [Narrative and style], a supplement to *Tema Celeste*, April 1998.

3. THE ANGELIC VS. THE MONSTROUS

This conversation took place via email in September 1998. It was published in *Tema Celeste*, October 1998.

4. ART CRITICISM AS ANALYTIC PHILOSOPHY (2012)

This conversation took place partly face to face at Danto's house, and partly via email between March and April 2012. It was published in Chinese in *ArtChina*, June 2012, 32–45, and partially in English and in Spanish in *Arte al Limite*, July–August 2012, 94–102.

1. Published in 1981.
2. The reference is to Jeff Koons's sculpture *Ushering in Banality*, from 1988.—Ed.

INDEX

Absolute spirit, 42

Abstract Expressionism, xvii, xxvi; Danto on, 64–65, 67–68; Greenberg on, 58–59; Kline contrasted with, 9–10; in New York, 13; Scully on, lii

Abstraction, 72; of modern society, 35–36, 41; post-painterly, 58–59, 62

Academia di Brera, xii

Action Painting, 8, 64, 66, 81

Advertising, commercial, 37–38, 64, 68–70

Aesthetics, xlix–l, 34–35; Danto on, xlvii–xlviii, 31–32, 72–74

Afghanistan, xxxix

African Americans, 72

After the End of Art (Danto), xliv

After Walker Evans (Levine), xxvii–xxviii

AIDS virus, 30

Alloway, Lawrence, 56

Altamira cave paintings, xxxiv–xxxv

American art, 58–59, 62, 68–70, 85–88. *See also specific artists*

American Museum of Natural History, xl

American Supermarket, The (exhibition), 92n5

97

Amsterdam, Netherlands, xli
Analytical Philosophy of History (Danto), 55
Analytic philosophy, 55, 63–64
Andina, Tiziana, x
Angels, 49–50
Anne (of Cleves), xli
Anscombe, Elizabeth, 64
Anselmo, Giovanni, 83–84
Appropriationism, xxvi–xxxi, xxix, 27, 84–85
Art: Danto definition of, xviii, xxi, 63; philosophical definitions of, xlvi, xlix. *See also specific subjects*
Art China (review), xii–xiii
Art criticism, xxv–xxvi, xlvi–xlvii, 57, 75; by Danto, xi, xlviii, 56; Danto on, 25–26, 67–68; by Greenberg, 58–59; philosophy of art compared to, 62–63
Artforum (magazine), x–xi
Artists, 5–6, 9–10, 75–79. *See also specific artists*
Art News Annual (magazine), 53
Art schools, 53–54, 64–65
"Art World, The" (Danto), 56, 71–72

Asia House gallery, 84
Associated American Artists, 54–55
Atomic bombings, xxxiv, xxxvi
Automatism, 81
Avant-garde art, 7, 28–29, 32, 82–83

Backgrounds (in pieces of art), xxx, xxxii–xxxiii, 19, 55–56, 69
Bacon, Francis, xxvi, 21
Barney, Matthew, 28, 47–48
Barry, Robert, 68
Baudelaire, Charles, 19
Beauty, xxiii–xxiv; in avant-garde art, 29; contemporary art and, xlviii–l; Danto on, l–li, 17–20; Duchamp and, 20–22, 76–77
Beijing, 82–83, 89
Bepler, Jonathan, 47
Bergman, Ingmar, 46
Beuys, Joseph, 36
Bianchini Gallery, 92n5
Bidlo, Mike, xxiv, xliv; appropriationism by, xxix–xxxi, 27
Black Sienna (Kline), 12
Bleckner, Ross, 30, 40

Boetti, Alighiero, xiii,
 xxxi–xxxix
Bottle Rack (Duchamp), 21
Brancusi, Constantin, xxx
Brera Academy, 4
Brera gallery, 22
Brillo Box (Warhol), xv–xvii,
 xxii, xlvi; Danto on, 56,
 66–67, 70–72
Bruegel, Peter, liii–liv
Buddhism, 51

Cahier d'Art (magazine), 64
California, xl
calligraphy, 89
capitalism, 43, 70, 86–87
Cappuccio, Elio, xiii
Castelli, Leo, 69, 71
Castiglione, Giuseppe, 82
Castro, Fidel, xli
China, xii–xiii, 78–79, 82–89
Chinese art, 57, 74–75, 81–89
Christ, 5, 49
Churches, icons used by, 4–5
Cimabue, 1
Cinema, 43, 46–48, 51; motion
 in, 44–45, 49–50
Classical art, 32
Coca-Cola, 69–70, 79–80, 87

Colombo, Giorgio, xiv
Color, 10, 29, 64
Colorado, 55
Columbia University, x–xi,
 55–56, 70
Commercialization, of art, 68
Commercial products, xvi–xvii,
 xxii, 36–37
Communism, 59
Comparativism, philosophical,
 xxxi
Conceptual art, xxvi, xxxiv, 7,
 60, 67–68
Conservativism, artistic, 48
Contemporary art, l, 57, 72;
 Chinese, 82–89; Danto on,
 xlvii–xlix; Greenberg on,
 58–59; objective truth and,
 lv–lvi
Contemporary Gallery, 54–55
Copies, original *vs.*, xvi–xviii,
 xxi–xxiii, xxxi
Courbet, Gustave, lvi
Cowboys (Prince), xxix
Cremaster 5 (Barney), 47–48
Cristo e L'impronta dell'Arte
 (Paparoni), x
Cubism, 67
Cybernetics, 38

Dadaism, 28–29, 81

Dahl, Johan Christian, 74, 75

Danto, Arthur C., *lix–lxiv.*
See also *specific topics*

Date Paintings (Kawara), xiii,
xxxiii–xxxviii

Daumier, Honoré, lvi

Death, 15–16, 31, 56; of Boetti,
xxxviii; of Danto, ix–xi; in
Kline artworks, 11–12

Death of art, xviii, xlvii, 14

Death of Art, The (Danto), xlvii

Deconstruction, in art, lii–liii

Déjeuner sur l'herbe (The
Luncheon on the Grass)
(Manet), 32

Détail (Opalka), xxxii–xxxiii

Detroit, Michigan, 53–54

Dewey, John, 35

Dickie, George, xxiii

Diebenkorn, Richard, 8

Dilthey, Wilhelm, 31, 39

Dine, Jim, 15, 69

Dioramas (Sugimoto), xl

Disrespect, 78–79

Drawings, 36, 48–49; by Kline,
8–9

Duchamp, Marcel, xv, 34,
81–82; beauty and, 20–22,

76–77; intentions of, 76–79;
readymades by, xvii–xxii,
xlix, 40

Eastern culture, 78–79

Education, for Danto, 53–55

Eisenstein, Segei, 46

Embodied meaning, xvii, xxiii,
xlvi, 62–63

Emotions, 48–49

Emptiness, 18, 22

End of art (concept), xv–xvi,
xlvi–xlvii, 14

End of history (concept), 10,
13–17, 25

End of narrative (concept), 10,
25–27

energy, in art of different scales,
2–4

Engels, Friedrich, 59, 70

Enlightenment, 28

Ensembles, installation as
distinct from, xlv, 93n9

Esperanto, xxxiii

Ethics, xlviii

European art, 58, 62, 68–70,
76

Evan, Walker, xxvii–xxviii

Existentialism, 61

Expressionism, 7, 10, 54. *See also* Abstract Expressionism

Expulsion from the Garden of Eden, The (Masaccio), 20

Fairy tales, 16

Fall of Icarus, The (Bruegel), liii–liv

Fellini, Federico, 46

Feminism, 80

Figurative art, xx–xxi, xxv–xxvi, li, 39, 62

First and Last (exhibition), xxvii–xxviii

Flack, Audrey, 65

Fluxus, 60, 67

Foregrounds (of art pieces), 55–56

Forgery, 66

Formalism, xxv, li, 11, 59, 62

Fountain (Duchamp), xix–xx

France, xix, 55, 82–83, 85, 88

Freud, Lucien, xxvi

Fried, Michael, 33

Fulbright Fellowship, for Danto, 55

Galerie Bruno Bischofberger, xxx

Gazes, xxvii, 73

Gemito, Vincenzo, lvi

Gender, 64–65, 80

Generazione delle immagini, La (The generation of images, conference), xii

Germany, lvii, 85

Giacometti, Alberto, 22

GI Bill, U.S., 53, 55

Gilbert and George (artist duo), 81

Globalization, 65–66, 80

Gober, Robert, xiii, xliii–xliv

Godzilla, 50

Goldin, Nan, 28–30

Gongkai, Pan, 85

Gongxin, Wang, 82

Great Criticism (Guangyi), 87–88

Great Depression, xxvii–xxviii

Greenberg, Clement, xxv, li, 14–15; Danto compared to, 56–62; Danto on, xii–xiii

Grocery stores, xvi, 66, 92n5

Guangyi, Wang, 79, 84, 87–88

Guggenheim, Peggy, xxix

Guston, Philip, 53

Hafif, Marcia, 65

Halley, Peter, 15, 40

Happy New Year (Qingsong), 83

Harvey, James, xvi–xvii, xxi–xxii

Hegel, Georg Wilhelm Friedrich, xv, xviii, xlvi–xlvii, 16, 42, 63

Henry VIII (King), xli

Hesse, Eva, 65

Hiroshima, Japan, xxxiv

History, lvii, 14, 16, 17–18; interpretations of art and, lii–liv, 74–75; linear progression of, xxv–xxvi, xxxi–xxxix; style and, 26–29, 36–39. *See also* End of History (concept)

Hitchcock, Alfred, xliv–xlv, 93*n*8

Hockney, David, xxvi

Hokusai, Katsushika, 88

Holbein, Hans (the Younger), xli

Homen, Antonio, 78

Homer, 50

Homosexuality, 30

Horror, 50

Hughes, Fred, 79

Hultén, Pontus, 66

Iacobelli, Natalia, xiv

Icons, as artworks, 3–5

Iliad (Homer), 50

Imitation, 39, 72

Impersonal style, 4–7, 35

Impressionism, 33, 67, 88

Impressionist, 67

In Advance of the Broken Arm (Duchamp), xviii–xix

Influence, in art, 34–35, 82–83

Installation art, xlv, 48, 83, 88–89, 93*n*9

Intellectualism, xi, 4, 34, 57, 60–61

Intention (Anscombe), 64

Intentions, 35, 75–79

Internet, 35–36, 41, 84

Interpretation, in art, lii–lviii, 32–33, 72–75

Invisibility, of the future, 33, 36, 46–47

Iranian Revolution, 65

Italy, x, xiv, 15–16, 18, 50, 53, 85; Kline in, 12–13; Milan, xii

Izu Waxwork Museum, xl

Japan, xxxiv, xl

Japanese art, xl, 69, 88–89

Joyce, James, 11, 46

Judd, Donald, xxvi, 19
Judgment of Paris, The
 (Raimondi), 32
Judy's Bedroom (Reed), xliv–xlv,
 93*n*9

Kant, Immanuel, 55, 59, 88
Kapoor, Anish, lvii, 40
Kawara, On, xiii, xxxi–xxxviii
Kiefer, Anselm, lvii
Kiss, The (Lichtenstein), 69
Kline, Franz, 8–10, 11–13
de Kooning, Willem, xxv, 71
Koons, Jeff, 71
Kounellis, Jannis, 40
Krause, Rosalind, 71
Kubler, George, 38–39
Kurosawa, Akira, 46
Kuspit, Donald, 57
Kwan Yin, 51

Lang, Fritz, 46
Langer, Susanne, 55
Lasker, Jonathan, 27
Lectures on Aesthetics (Hegel),
 xlvi
Léger, Fernand, xxx
Legitimacy, of art, xxx, xlvi,
 xlix, 26, 28–30, 77

Levine, Sherrie, xxiv,
 xxvii–xxviii, xliv, 27
LeWitt, Sol, xxvi, 6, 65
Lichtenstein, Roy, xxv, 69, 70,
 76, 77, 88
Lijun, Deng, 87
Linear progression, of history,
 xxv–xxvi, xxxi–xxxix; Reed
 challenging, xliv–xlv
Linguistic plurality, in art,
 36–37
Literature, 11, 45–47, 50, 62, 65
London, United Kingdom, xli
Lumière brothers, 44–45
Luncheon on the Grass, The
 (Déjeuner sur l'herbe)
 (Manet), 32

Madame Tussaud, wax
 museums, xli
Mancini, Antonio, lvi
Manet, Edouard, 32–33, 62, 69,
 82, 88
Mangold, Robert, 65
Manzoni, Piero, 22
Mao, Zedong, 78–80, 85, 87
Mappe (Boetti), xxxix
Mapplethorpe, Robert, li
Marlboro, xxix

Marx, Karl, 16, 59, 70, 80
Masaccio, 20
Mass communications, 69
Materials, xxii, lvi, 66–67; in
 sculptures, 6–7, 22, 65
Matta Clark, Gordon, 65
Max Protech gallery, 84, 93n9
McLuhan, Marshall, 38
Mechanical processes, 8–10
Meyer, Melissa, 27
Michigan, 53–54
Milan, Italy, xii
Military service, of Danto, 53,
 60–61
Millet, Jean-François, lvi
Mind (magazine), 64
Minimalism, xxvi, xxxvi, lvi, 7,
 60, 65–67
Minini, Massimo, 68
Minjun, Yue, 83, 86, 88
Miss, Mary, 65
Modernism, xxxii, lv, 14–15, 22,
 49, 84; Greenberg defining,
 xxv, 33, 58–59, 62; linear
 progressive time in,
 xlii–xliii; Manet initiating,
 32–33, 62
"Modernist Painting" (Green-
 berg), 33, 58–59

MoMA. See Museum of
 Modern Art
MoMA PS1 museum, xxix–xxx
Monet, Claude, xlii–xliii, 33
Monroe, Marilyn, 87
Monsters, 50–51
Morality, truth and, 30
Morandi, Giorgio, xxx
Morocco, 53
Motherwell, Robert, 2, 11, 57
Motion, in cinema, 44–45,
 49–50
Movieland Wax Museum, xl
Mu (nothingness), 89
Museum of Modern Art
 (MoMA), xxvii, xxix, 77
Music, in cinema, 47–48
My Personal Universe (Wang),
 88–89

Nagasaki, Japan, xxxiv
Namuth, Hans, xxix
"Narrative and Style" (Danto), ix
Narratives, in art, 10–15, 28, 58,
 62; cinema compared to,
 45–49; Danto on, 25–26,
 32–33
Nation (journal), 55–56, 60
Naturalism, 31

Neo-Expressionism, xxvi

Neri Pozza, xiv

Netherlands, xli

Newton, Isaac, lv

New York, ix, xvii–xviii, xl,
8, 82–83; Abstract
Expressionism in, 12–13;
Danto in, 54–55, 84

New Yorker (magazine), ix, 61

New York University, 54

Nietzsche, Friedrich, 63

Not Andy Warhol (exhibition),
xxx

NOT Andy Warhol's Factory
(exhibition), xxix–xxx

Nothingness, 88–89

Not Pollock (Bidlo), xxix

Not Warhol (Brillo Boxes 1964)
(Bidlo), xxx–xxxi

Obama, Barack, 79

Objective truth, lv–lvi

Objects, 15; art compared to,
xv–xvii, xlvi–xlviii, 26, 76–77;
readymades and, xviii–xxii,
76–77

Oldenberg, Claes, 69, 86

Opalka, Roman, xxxi–xxxiii,
xxxviii

Operas, 46

Originals, copies *vs.*, xvi–xviii,
xxi–xxiii, xxxi

Orlan, 40

Pace gallery, 84

Paintings, 53, 65, 77, 82, 85;
cinema compared to, 43–44,
49; by Danto, 54–55, 63; by
Kawara, xxxiii–xxxvi; by
Kline, 9–10, 11–12; by Monet,
xlii–xliii; by Opalka,
xxxii–xxxiii; by Paladino,
6–8, 10–11; by Scully, 41, 57;
sculptures compared to,
22–23

Pakistan, xxxix

Paladino, Mimmo, xii, 2–4, 40;
on beauty, 17, 20; on death,
15–16; on impersonal art, 6–7;
paintings by, 6–8, 10–11

Paparoni, Demetrio, ix, 1, 3, 21,
74; on Chinese art, 81–89; on
cinema, 43, 46, 50; on
Greenberg, 58–59; on
postmodernism, 80; on
styles and history, 27–29

Paris, France, xix, 82–83

Partisan Review (journal), 61, 62

Performance art, 31, 65, 84

Perniola, Mario, ix, 30–31, 38–40

Philosophical Disenfranchisement of Art, The (Danto), ix

Philosophy, xv, xxxi, xlvi–xlvii, 34–35; analytic, 55, 63–64; Greenberg and, 60

Philosophy, of art by Danto, x–xiii, xxii–xxiii, xlix, 13–14, 26; art criticism compared to, 62–63; commercial advertising in, 69; education toward, 53–55; on nothingness, 88–89

Photography, xxix, lvi, 28, 40, 44, 81; aesthetics and, 34–35; by Levine, xxvii–xxviii; by Opalka, xxxiii; by Sherman, xxvi–xxvii; by Sugimoto, xl–xlii; women and, 65, 80

Picasso, Pablo, xxx, 23, 53

Piero della Francesca, 27, 75

pigeons, vision of, 72–73

Pinacoteca Ambrosiana (Ambrosiana gallery), 48–49

Pinacoteca di Brera (gallery), xii

Pinto, Roberto, xii

Planisfero politico (Boetti), xxxix

Plato, 72

Plays, cinema preceded by, 45–46

Political, art as, xxxix, 11, 71–72, 79, 87

Pollock, Jackson, xxvi, 60; Bidlo appropriating, xxix–xxxi

Pop art, 64, 66–67, 69, 77; Chinese art and, 84–87; by Lichtenstein, xxv, 70–71

Portraits, xli, 81; self, xxxii–xxxiii, 76; by Warhol, 76, 78–79

Postcards, xxxiv, xxxvii–xxxix

Posthistory, xxiv, xliv, 26–27; Reed exemplifying, xliv–xlv; Sugimoto as precursor to, xl–xliii. *See also* Linear progression, of history

Postmodernism, xxxii, lv–lvi, 64, 80; posthistory vs, xxiv

Post-painterly abstraction, 58–59, 62

Postwar period, xxvi, 14

Prince, Richard, xxiv, xxviii–xxix, xliv

Principia (Newton), lv

Prints, 54, 63, 71, 88

Propaganda, 64, 78, 87

Qingsong, Wang, 83–84

Raimondi, Marcantonio, 32

Raphael, 49

Rawls, John, 64

Readymades, xvii–xxii, 40;
 beauty and, 20–22

Realism, 28, 39–40, 70

Red Double Happiness, 87

Reed, David, x–xi, l, 27, 57;
 Judy's Bedroom by, xliv–xlv,
 65, 93n9

Regan, Ronald, xxviii

Religion, 4–5, 42, 51

Rembrandt, 12

Renaissance, lv, 75

Representation, 15, 45, 81

Republic (Plato), 72

Resurrection (Piero), 75

Retinal art, xvii–xviii, 77

Richter, Gerhard, 86

Rights, xxviii, 53, 62

R. Mutt (pseudonym), xix–xx

Robert Elkon Gallery, 54–55

Romantic art, 28

Rosenquist, James, 69

Rosso, Medardo, xii, 22

Rothko, Mark, l, 57

Rovetch, Shirley, 54

Ruscha, Ed, 69

Ruskin, John, 18, 56

Russell, Bertrand, 63–64

Russia, 85

Ryman, Robert, xxvi

Sacredness, in icons, 4–5

Sallis, John, xliii

Salon des Refusés, 32

Samorì, Nicola, xiii–xiv

San Francisco Art Institute,
 xliv–xlv

Sartre, Jean-Paul , 61

School of Athens (Raphael), 49

Schwarzkogler, Rudolf, 40

Scottie's Bedroom (Reed), 93n9

Scully, Sean, xliv, xlix–l, 27, 30,
 40, 65; on abstract
 expressionism, lii; Danto on,
 57; paintings by, 41

Sculptures, xii, 19, 68; materials
 for, 6–7, 22, 65; paintings
 compared to, 22–23; women
 and, 65, 80

Seeing and Showing (Danto), 81
Segantini, Giovanni, lvi
Self-portraits, xxxii–xxxiii, 76
Senaldi, Marco, xii
Sentimental Moment (Guston), 53
Serie di merli disposti a intervalli regolari lungo gli spalti di una muraglia (Boetti), xiii, xiv, xxxvii–xxxviii
Serrano, Andres, li, 28–30
Sherman, Cindy, xxiv, xxvi–xxvii, xxxvi, xliv, 65, 80–81
Silent films, 47
Silkscreen, 4, 66, 77–78
Silver Factory, 66
Simonds, Charles, 65
Sisley, Alfred, 33
Size/scale of artworks, 1–4
Slides of a Changing Painting (Gober), xiii, xliii–xliv
Smithson, Robert, 65
Société des Artistes Indépendants, xix
Society, abstraction of, 35–36, 41
Society of Independent Artists, xix–xx
Socrates, 72
Sonnabend Gallery, 78–79

Sorbonne university, 55
Soviet Union, xxxix
Special effects, in cinema, 45–46, 48
Sperone, Gian Enzo, xxxvii–xxxviii, 68
Spirituality, in art, 11, 15–16, 28–30, 39–42, 88
Stable Gallery, xv–xvii, xxiv, 66, 71
Stieglitz, Alfred, xx
Stories, as art form, 45–46
Style, in art, xxiv, 31–32, 77, 86; history and, 26–29, 36–39; impersonal, 4–7, 35
Suegkaub, Seth, 68
Sugimoto, Hiroshi, xl–xlii, xliv
Summer of Freedom, U.S., 72
Surrealism, xxv, 81
Sweden, 66
Switzerland, xxx, 18
Sylvester, David, 33–34
Symbols, in art, 21–22

Tang Contemporary Art, 83
Technology, 41, 43–46, 48
Telegrams, xxxiv, xxxvii–xxxix
Tema Celeste (magazine), ix, xii, 15

Theaters (Sugimoto), xlii
Thiebaud, Wayne, 69
Tianmiao, Lin, 82
Time, xxxi–xxxiii, 13; in the
 work of Gober, xliii–xliv;
 in the work of Monet,
 xlii–xliii; in the work of
 Sugimoto, xl–xlii
Titan, 1
Titanic (film), 48
Today (Kawara). *See Date
 Paintings* (Karawa)
Tolstoy, Leo, 13
Totalitarian art, 85
"Toward a Newer Laocoon"
 (Greenberg), 58
*Transfiguration of the
 Commonplace, The* (Danto),
 liii, 56
Translation, ix, xii–xiii
Truth, in art, lii–lvii, 30, 31
291 Gallery, xx
Two Bedrooms in San Francisco
 (Reed), 93
Typewriters, use of, xxxiv–xxxvii
Tzu, Chuang, 74–75

Ulysses (Joyce), 11
United Kingdom, xli

United States (U.S.), xxvii–xxviii,
 53, 55, 61, 64–65; Summer of
 Freedom, 72. *See also specific
 states*
Universality, in art, 74–75
University of Colorado, 55
Untitled Film Stills (Sherman),
 xxvi–xxvii

van Gogh, Vincent, 88
Vassari, Giorgio, 14–15
Veronese, Paolo, 18
Vertigo (film), xliv–xlv
Vie, La (Picasso), 53
Vietnam War, 64
Virgin (Madonna), the, 5, 49
Visibility, of the present, 30–33
Visual texts, 73–74

Wagner, Richard, 46
Wang, Zhang, 88–89
War, 53, 61
Ward, Eleanor, 71–72
Warhol, Andy, xxiv, xlix, 4–5,
 36; *Brillo Box* by, xv–xvii,
 xxii, xlvi, 66–67; Danto on,
 56, 66–67, 70–72, 76–79; Mao
 portraits by, 78–79
Wax sculptures, xii, xl–xli, 22

Wayne State University, 53–54

Wenders, Wim, 46

Wesselmann, Tom, 69

Western culture, xxii, 41–42, 67–70; universality determined by, 74–75

Western culture, Eastern culture and, 82–89

Westman, Barbara, ix, xxx

Wild Strawberries (film), 48

Wittgenstein, Ludwig, 63–64, 89

Women, in art, 64–65, 80

Woodblocks, 54

Woodman, Francesca, 65, 80

Yi, Ding, 57

Zola, Èmile, 69, 88

Zurich, Switzerland, xxx, 18

Columbia Themes in Philosophy, Social Criticism, and the Arts
Lydia Goehr and Gregg M. Horowitz, Editors

Lydia Goehr and Daniel Herwitz, eds., *The Don Giovanni Moment:*
Essays on the Legacy of an Opera

Robert Hullot-Kentor, *Things Beyond Resemblance: Collected Essays on*
Theodor W. Adorno

Gianni Vattimo, *Art's Claim to Truth*, edited by Santiago Zabala,
translated by Luca D'Isanto

John T. Hamilton, *Music, Madness, and the Unworking of Language*

Stefan Jonsson, *A Brief History of the Masses: Three Revolutions*

Richard Eldridge, *Life, Literature, and Modernity*

Janet Wolff, *The Aesthetics of Uncertainty*

Lydia Goehr, *Elective Affinities: Musical Essays on the History*
of Aesthetic Theory

Christoph Menke, *Tragic Play: Irony and Theater from Sophocles to Beckett*,
translated by James Phillips

György Lukács, *Soul and Form*, translated by Anna Bostock and edited
by John T. Sanders and Katie Terezakis with an introduction
by Judith Butler

Joseph Margolis, *The Cultural Space of the Arts and the Infelicities*
of Reductionism

Herbert Molderings, *Art as Experiment: Duchamp and the Aesthetics*
of Chance, Creativity, and Convention

Whitney Davis, *Queer Beauty: Sexuality and Aesthetics from Winckelmann to Freud and Beyond*

Gail Day, *Dialectical Passions: Negation in Postwar Art Theory*

Ewa Płonowska Ziarek, *Feminist Aesthetics and the Politics of Modernism*

Gerhard Richter, *Afterness: Figures of Following in Modern Thought and Aesthetics*

Boris Groys, *Under Suspicion: A Phenomenology of the Media*, translated by Carsten Strathausen

Michael Kelly, *A Hunger for Aesthetics: Enacting the Demands of Art*

Stefan Jonsson, *Crowds and Democracy: The Idea and Image of the Masses from Revolution to Fascism*

Elaine P. Miller, *Head Cases: Julia Kristeva on Philosophy and Art in Depressed Times*

Lutz Koepnick, *On Slowness: Toward an Aesthetic of Radical Contemporaneity*

John Roberts, *Photography and Its Violations*

Hermann Kappelhoff, *The Politics and Poetics of Cinematic Realism*

Cecilia Sjöholm, *Doing Aesthetics with Arendt: How to See Things*

Owen Hulatt, *Adorno's Theory of Philosophical and Aesthetic Truth: Texture and Performance*

James A. Steintrager, *The Autonomy of Pleasure: Libertines, License, and Sexual Revolution*

Paolo D'Angelo, *Sprezzatura: Concealing the Effort of Art from Aristotle to Duchamp*

Fred Evans, *Public Art and the Fragility of Democracy: An Essay in Political Aesthetics*

Maurizio Lazzarato, *Videophilosophy: The Perception of Time in Post-Fordism*, translated by Jay Hetrick

Monique Roelofs, *Arts of Address: Being Alive to Language and the World*

Barbara Carnevali, *Social Appearances: A Philosophy of Display and Prestige*

Emmanuel Alloa, *Looking Through Images: A Phenomenology of Visual Media*

Jason Miller, *The Politics of Perception and the Aesthetics of Social Change*

Printed and bound by CPI Group (UK) Ltd, Croydon, CR0 4YY

02/04/2024

14478113-0001